PHOTOGRAPHY FOR THE ART MARKET

PHOTOGRAPHY FOR THE ART MARKET

KATHRYN MARX

AMPHOTO
AN IMPRINT OF WATSON-GUPTILL PUBLICATIONS/NEW YORK

First published 1988 in New York by AMPHOTO, an imprint
of Watson-Guptill Publications, a division of Billboard
Publications, Inc., 1515 Broadway, New York, NY 10036.

Library of Congress Cataloging-in-Publication Data

Marx, Kathryn.
 Photography for the art market / Kathryn Marx.
 p. cm.
 Includes index.
 ISBN 0-8174-5444-6 ISBN 0-8174-5445-4 (pbk.)
 1. Photography, Artistic. 2. Photography—Collectors and
collecting. I. Title.
TR642.M365 1988
770—dc19 87-31916
 CIP

Manufactured in Japan

1 2 3 4 5 6 7 8 9 / 93 92 91 90 89 88

Editorial concept by Susan Hall
Edited by Liz Harvey
Designed by Jay Anning
Graphic production by Ellen Greene

This book is dedicated to the memory
of my brother, Alfred Marx.

I would like to offer special thanks to Franco Fontana, Evelyn Roth, Constance deSwaan, Sandy Skoglund, Jean-Claude Lemagny, Ralph Gibson, Ann Rodiger, Ruth Morrison, Gloria Safier, Glorya Hale, Marisa Bulzone, Susan Hall, Liz Harvey, the Wednesday Night Writing Group, and Patricia Ann Mullen, without whose support and patience I never would have found my *f*-stop.

I would also like to thank each of the participating photographers for accepting and forgiving a fellow photographer for committing the crime all too frequently perpetrated against us: asking for samples of photographs without sufficient payment in return. My gratitude for your understanding.

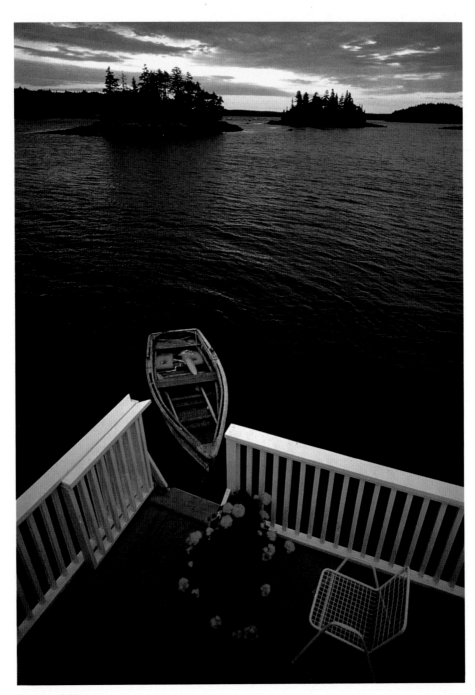

Sorrento, Maine.
© Harold Davis.

INTRODUCTION

© Bruce Davidson. Courtesy of Magnum Photos, Inc.

Years ago, photography was divided into two categories, good photography and bad photography. Today, countless categories exist: commercial, fine art, constructivist, appropriated, saturated, sentimental, journalistic, portrait, and on and on—the result of the evolution of new applications for photography and experimental techniques. "However, without the participation of intuition, sensibility, and understanding, photography is nothing," warns Henri Cartier-Bresson.

Photographers who wrestle with their own creativity, rather than with concepts that are dictated, prescribed, or suited to fulfill external demand,

face both the potential and the limitations of "fine art." But, as Edward Weston said more than fifty years ago in his book *Photography: Essays and Images*, "Limitations need not interfere with full creative expression; they may, in fact, by affording a certain resistance, stimulate the artist to fuller expression."

The term *commercial photography* is also troubling. Commercialism is often synonymous with materialism, is thought to stifle creative impulses. But an inspiration can come from anywhere. Eugène Atget's photographs of prostitutes in doorways are the result of a commercial assignment. When Ansel Adams worked for the War Department, he had the chance to proselytize about preservation. Although Walker Evans preferred to photograph on his own, he did some of his best work when he was part of the Farm Security Administration. Furthermore, without the supposedly crass caress of the commercial demand, how would photographers pay for darkroom space or studio rent? There's a difference between sacrificing your art for commercial gains and sacrificing commercial gains for the ponderous notion of the artist's obligatory starvation.

Several photographers discussed this issue with Emily Simson for *Photo/Design* magazine. "I've always used my commercial work to support my more personal ventures. Commercial and personal work do feed each other," says Bruce Davidson, creator of the book *Subway* and recipient of a Guggenheim fellowship. "I learn things technically doing my commercial jobs that I can use in my private work, and I learn things emotionally and spiritually that I can apply at times to my professional work." The primary difference between commercial and private work for Davidson, who is represented by the Witkin Gallery and Magnum is that his commercial work "doesn't come from that special place where my personal work emanates from."

Photographer Robert Mapplethorpe explains the resistance to commercial photography: "Many art photographers are afraid of commercial photography because they may be insecure or simply afraid they won't be able to please themselves and the client at the same time." In addition, he says, advertising work "opens new doors for me. I see it as a plus. Commercial work brought me into color photography. It got me involved with a certain kind of palette."

Joel Meyerowitz, whose work includes a New York Graphic Society book, *Cape Light*, exhibitions at the Witkin Gallery, and numerous advertising campaigns, puts the business of commercial photography in its most basic terms:

> I have a rubber stamp. That's my letterhead, you might say. When I need something, I make

it up on the spot. The interesting thing about this approach is that it suggests to me that you can break into the business. People think that it's an invulnerable fortress and you have to assault it by . . . self-promotion. That may help, but it isn't the only way in. The challenges in commercial work are fresh every time. There's no formula for turning out a response to a client's proposal.

The difference between commercial and "fine-art" photography is not so much the assignment as the way the photographer sees the external world through the internal eye. Great portrait photographers, for example, see each subject differently while mediocre photographers merely copy someone else's style. Showing your work to people other than friends and relatives who love everything you do is a good way to find out whether or not you are translating your ideas into effective photographs. This can mean having an exhibition or presenting your portfolio to editors of cards, calendars, or posters. Different kinds of work translate best in different ways. There are also photographers whose work may not translate until after their death because of changing interests and trends.

THE MAKINGS OF A FINE-ART PHOTOGRAPHER

Photographers have to come up with personal solutions to the artist's age-old dilemmas: how to do what you want to do, how to have enough money to do it, and how to earn this money the way you want to. Finding answers requires desire and endurance. For any photographer or creator of "fine art," obsession is one of the essential elements that turn this creative desire into an actual working process. Your obsession finds a way to pay the bills. You may have to wait out various trends or fads. You may be part of a whirlwind gallery trend. You may not care. You must survive.

Obsession can go a long way, but not far enough. The need for money can be restricting. A majority of photographers eventually put their work aside, continue it as a hobby only, and venture into a more lucrative field. Because the nature of creating a picture often means immediate gratification, many photographers assume that their success (whether material or purely psychological) will come just as quickly. For some, it does. For most, it doesn't. The odds are in favor of the artists who are encouraged by respected sources—having a dealer, gallery, publisher, or museum behind them increases the chances that their work will be accepted—and who persist, and persist, and persist. New photographers are often advised to study with someone to learn a certain technique

or style. For some, this is a gain; for others, a loss of time, individuality, and money.

What every photographer wants is a significant push toward the public and serious collectors. This usually comes only after you have taken numerous risks in exposing your work. Without changing or cropping your pictures any differently than you would for yourself, your photographs can be published as cards or posters readily if they fill a publisher's needs or you have the funds to publish them yourself. If you start a trend or come up with a hot new concept, you might end up showing your work in a museum or in exhibition tour.

Some photographers invest in themselves, supporting their publicly unsupported efforts through salable forms of photography, such as fashion work; other careers; other people's money; or self-publication—hoping that it will pay off. Some can afford to continue for the sake of their own satisfaction. Others decide to publish their own posters, cards, or books to maximize their income or to maintain artistic control over the finished product.

THE STATE OF THE ART

Photography has always been, to a certain degree, out of the mainstream of fine art; having it accepted by private and public collectors, such as museums, has been difficult. Because photography is the art form most closely associated with advertising, it is often still considered the petulant, overlooked child of the plastic arts. However, with more and more advertising firms hiring photographers to do exactly what they do best—and for their individual style— the distinction between fine-art pictures on display in galleries and commercial photography is becoming less and less apparent.

When photography is mixed with other media, the result can be separated, if necessary, to reveal photography as one of its ingredients. For some people, this type of art falls into the photography category. If the mixture of elements is integrated well, however, the result transcends its means to become an expression unto itself. Sandy Skoglund, a New York-based photographer, has created a special place for herself in the fine-art world. Although her photography makes use of her sculpture and painting, she has not been limited by the label of sculptor, painter, or photographer. Her success was readily apparent at the 1986 Mois de la Photo in Paris.

With more and more painters and sculptors using photographs to complete their work, photography is reaching a wider range of galleries and audiences. But are the photographic results automatically fine art?

To answer this, we must return to the subject

Photograph
© Jay Maisel.
Advertisement
© FannieMae.

of good versus bad photography. Is it enough that viewers be awed by technique? Are viewers merely to be manipulated as much as the appropriated or manipulated image? In some galleries and markets, this type of photography thrives; to move an audience with a picture is risky. For some corporations and private collectors, the more graphic the image, the better. Most publishers of cards and posters are also looking for pictures that pop out at viewers. But true collectors, who are as rare as fine art is fine, scrutinize a photograph's content closely. As Edward Weston says in *Photography: Essays and Images*:

> The mechanical camera and indiscriminate lens eye, by restricting too personal an interpretation, direct the worker's course toward an impersonal revealment of the objective world.

Clearly, some photographic trends are more marketable than others. "Constructivist, rational imagery transfers handily onto editorial pages and promotions for technology," notes Vicki Goldberg, contributing editor of *American Photographer* magazine. She continues:

> Through no real fault of the art, certain kinds of geometric and cool, intellectualized abstractions have come to be regarded as perfect for corporate collections ... handsome, unthreatening, safe, prestigious. What fits comfortably on office walls evidently fits comfortably into certain branches of mass media as well. This represents quite a change: corporate America has rarely managed to swallow the avant-garde whole before.

In the future, when the element of reality in photography is used to manipulate viewers to accept the artificial as real, will viewers then accept the staged image as such or simply regard the picture for its graphic design? As Henri Cartier-Bresson said in 1968:

> Photography is an instantaneous expression of the world in visual terms, and a perpetual quest and interrogation. The camera is an admirable instrument for seizing upon life as it presents itself. A photographer must always work with the greatest respect for his subject and in terms of his own point of view. That is my own personal attitude; consequently, I have a marked prejudice against "arranged" photographs and contrived settings.

The extensive use of photographs by mass media places more and more responsibility on photographers. We must take greater care than ever not to allow ourselves to be separated from the real world, from humanity. As Ansel Adams said, "Our next step should be the relation of this technique (photography) to a more thorough and inclusive aesthetic expression." The question for the individual photographer is the balance between the mask and the self, the photograph and the method of expression, the tool and the craft, the means and the result.

Where does this leave photography? Different opinions make the field and create different collectors, publishers, and successes. Different opinions keep the photography market alive. It is your survival in this market that this book addresses. You can make it. There is no one right way. The various markets include magazines, books, cards, calendars, and posters. If no market for your work exists, you can create your own. You will know soon enough if you are looking through the viewfinder of delusion: your money or your patience will run out. If not, perhaps you will decide whether or not to keep shooting or to change professions. You should feed on your instincts, swallow them, and live by them.

Radioactive Cats.
© Sandy Skoglund.

GALLERIES

Twisted Tree, Point Lobos, California. © 1951 Minor White.
Courtesy of The Art Museum, Princeton University.

The gallery's success depends largely on three essential elements: a dealer or director, a collector, and a photographer. When the three work well together, the gallery becomes the fine-art connection between a photographer's point of view and the public's appreciation of this personal vision.

In 1954 Helen Gee, through her personal vision, opened the Limelight Gallery in New York, the first gallery devoted exclusively to photography. Gee's list of photographers included Berenice Abbott, Ansel Adams, W. Eugene Smith, Robert Frank, Edward Weston, Brassai, Lisette Model,

Alfred Stieglitz, and Minor White, among others. As Peter Bunnell, McAlpin Professor of Photography and director of the art museum at Princeton University, recalls,

> The Limelight was a meeting place and a socializing force for all photographers. There was a sense of everyone working for a cause, what Stieglitz used to call "the struggle," and had at its core a belief in the rightness of the medium as the expressive vehicle of our time.

Although much has changed since 1954, photography is still one of the expressive media, and photographers and galleries are still involved in "the struggle." By showing contemporary art, galleries continue to take risks: exposing work that might otherwise remain unseen and supporting photography in a world still not entirely ready to regard it as an art form.

"Photography sells in trends," explains gallery owner Marge Neikrug. At present there are two major trends within the gallery world. Some galleries choose to exhibit media other than photography, such as sculpture, with an exhibition of photography. This reflects a change in the essence of photography. Other galleries are "purists" and continue to let photography stand alone. Photography is still striving for complete legitimacy. The questions are these: To what degree should photography be assimilated into the mainstream of art? Should it remain apart, to be shown apart? If the trend in diversified approaches to photography continues to grow, the field will need every kind of gallery conceivable so photography and photographers can evolve.

THE GALLERY'S ROLE

Galleries can help photographers find their audience, establish their name, or enhance their reputation. Galleries also offer photographers the space needed to show a work in its entirety. The exposure is invaluable.

During Mark Feldstein's transition from

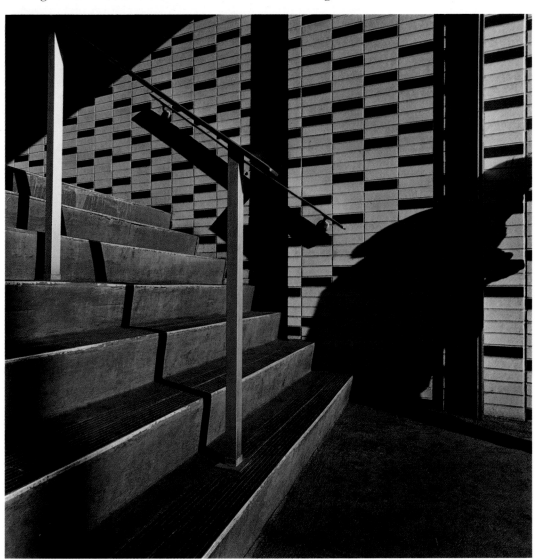

© Mark Feldstein.
From *Sightings*.

painter to photographer, he photographed the light/dark pattern of cast iron in New York. The New York Historical Society's curator, Mary Black, included this work in several huge exhibitions about the urban area. Feldstein explains the shows' impact on his career:

> The exhibitions got a lot of attention; they were well reviewed and were seen by a lot of people. The first body of work was exhibited and then published as *Unseen New York*, a Dover book. Much later, *Sightings*, a Chelsea House book, was published. I did a stage set a few years ago for a Broadway play, *The Tap Dance Kid*, because the set designer had seen the exhibitions and the book.

For the photographer, the exhibition can determine where your career may go. In addition to teaching at Hunter College, Feldstein has had many international exhibitions, sells primarily to private collectors, and has the freedom to continue his work. Nan Goldin's career took a similar turn. As a result of her exhibitions in Europe and the United States, which number more than forty, a collection of her photographs was published as *The Ballad of Sexual Dependency*. Jean-Marc Tingaud, who was renowned in France for his *publicité* photography, was given an exhibition by the Ministry of Culture in the palatial Espace Vendôme. Afterward his public grew tremendously, and his images were shown during the 1986 Mois de la Photo.

Galleries are also the most open "market" for photographers whose work is highly unusual or provocative. Jean-François Sirabella, director of Espace Canon, is well known for his risk-taking with innovative photographers. Galleries like this, which expose rather than deal, can help you find your public and let them find you. Aram Dervent's unconventional images are most frequently purchased in France by the Ministry of Culture, the Bibliothèque Nationale, and private collectors. A corporation would not want Dervent's photographs decorating its office walls, any more than it would buy Joel-Peter Witkin's. Neither photographer's work would likely be purchased by publications wanting to appeal to the mass market.

Like Dervent, Touhami Ennadre is another French photographer whose startling and most assuredly "nondecorative" work is guided through his gallery's network of supporting collectors. Similarly, without the galleries who took the first risk with Irina Ionesco's photography, magazine and book publishers would not have seen her work and published so many of her images.

For those photographers who prefer the mechanics of perfecting images to the mechanics of the art world, a gallery with a devoted director who arranges sales and additional exhibitions is a great plus. This type of director will see to it that your work is included in significant exhibitions that mixed audiences attend. Bernard Faucon continued to work in Paris while being represented by the Houston Center for Photography at the 1986 Houston Foto Fest in Texas. Collector Harry Lunn exhibited Joel-Peter Witkin's images during the 1986 Mois de la Photo in Paris while Witkin continued to work in the United States. Witkin's work is now internationally acclaimed. As photographer Mark Feldstein points out, few artists work exclusively with one gallery or one dealer: "Whatever success one dealer has only heightens the measure of success for the other."

Photographs © Jean-Marc Tingaud.

Harvest. © 1984
Joel-Peter Witkin.

Brian with Three
Beds. © Nan Goldin.

Les Mandarines.
© 1982 Bernard
Faucon.

FINDING A GALLERY

Many fine-art photographers are poorly advised to look at a gallery as the ultimate bridge between the private notion of possessing great talent and the reality of being successful. Some photography can be marketed more effectively in the form of books, posters, or cards. But if your photographs are not decorative, and you don't expect a steady cash flow as a result of your pictures, showing your work through galleries is a logical course to pursue. Arm yourself with patience, a sizable ego, and another source of income. Galleries attract more viewers than buyers.

Finding a gallery can take a long time while photographers show their portfolios at one gallery after another without receiving a response. The search can end with a curator or dealer who believes in a photographer—and with the photographer's acceptance that there isn't much loose cash lying among an abundance of empty film canisters. But it may be quite a while before the photographer, the dealer, and a collector agree on the same picture at the same time with equal enthusiasm. Barbara Pfeffer was one of the first photographers to shoot male nudes in the early 1970s. But back then, galleries were showing only female nudes. Pfeffer's work met with great resistance until 1972, when the Neikrug Gallery held a group show entitled "Rated X" and included some of Pfeffer's male nudes.

The gallery is not just a place. It is composed of people—subjective, opinionated people. For particular types of images, especially those that involve taking risks, photographers must find particular galleries. Some photographers must travel in order to locate appropriate galleries. Most likely, Helmut Newton would not have found a public for his visceral style had he stayed in Australia.

Finding the gallery means exposure, the important first step. You will learn whether or not your photography speaks for itself. Are others seeing what you hoped to reveal in an original way? Is it as original as you thought? As former gallery owner Cortia Worth points out, new photographers "should go through the process of exposing their work to the public, even if it's eight prints. They can start to rate their own level of objectivity about their own work." Gallery directors are shocked by most photographers' limited knowledge of the history of photography, as well as photography's relationship to other art forms. Worth adds, "What most people need in the beginning is just to get feedback and exposure."

Cupid and Psyche, 1986. © Calum Colvin. Courtesy of The Photographers' Gallery, London.

Male Nude and Reclining Woman. © Barbara Pfeffer.

For many photographers, the first exhibition—the first exposure—has the strongest influence on their work. "These are the smaller shows at lesser-known places or unknown places," says Mary Ann Fulton, associate curator of the George Eastman House. "There are schools, a small gallery in a town they live in. It gives photographers the opportunity to see their work and talk to other people about it."

A photographer can never be overexposed. If you continue to grow and change, you need continual feedback on your work to know its effectiveness. The gallery can offer a photographer great momentum. Michele Chomette, owner of a private gallery in Paris, feels the relationship between the photographer and his or her dealer is based on trust:

> They must really function like two people on the same bicycle. The two must pedal in the same direction as far as possible. From time to time, one is in the front and the other in the back. Then they reverse the arrangement.

A gallery dealer's integrity is a characteristic every photographer should consider. It determines the exhibitions in a particular gallery as well as the gallery's reputation and loyal collectors. In addition, the dealers' sense of the market is crucial in terms of keeping the photographers, the collectors, and themselves afloat. The close relationship you share with a gallery dealer starts with your photographs.

© Helmut Newton.

Le Louvre Revisité.
© Christian
Milovanoff.
Courtesy of Galerie
Michele Chomette.

Polaroid on Silk.
© 1986 Paolo Gioli.
Courtesy of Galerie
Michele Chomette.

PRESENTATIONS AND SUBMISSIONS

With the exception of your own home, a gallery is the only place where you don't have to compromise your work. The director will either like it or not like it. Since the field is saturated with the images of countless new photographers, galleries do not bother to mince words concerning their preferences.

Taste, however, is very subjective. Marge Neikrug, owner of New York's Neikrug Gallery since 1970 and member of the American Society of Appraisers, prefers images that the photographer is proud of and that are thematically cohesive. Other directors have different criteria for photographic content. Mary Ann Fulton, associate curator of the George Eastman House, looks for the photograph that transcends its subject matter and causes an emotional reaction. Evelyn Daitz, director of the Witkin Gallery, agrees: "The photograph has to move me in every sense . . . visually, technically, and emotionally."

Photographs that offer a new vision are sought out by Carol Williams, curator of the Photography West Gallery in Carmel, California, while the director of London's Photographers' Gallery, Sue Davies, enjoys both innovative and classical images. Jean-Claude Lemagny, curator of the Bibliothèque Nationale, says that a photograph must speak for itself. Toronto gallery owner Jane Corkin looks for images that can stand alone, that have the "ability to move around and do the things that objects on a picture frame have to do."

It is easy to forget just how many other photographers submit their portfolios to galleries. Every other artist thinks his or her portfolio is special. Presenting a portfolio can be disappointing.

In general, submitting work to a gallery for a critique is a fast process. Some directors are quite willing to tell you why they like or dislike your photography; gallery owner Marge Neikrug says that she rarely lets photographers pick up their portfolios without an encouraging word. Other directors leave only a receipt with your portfolio, and still others don't even acknowledge that they have seen it. This may simply be a matter of policy, as at the Center for Creative Photography in Tucson, Arizona, not an attempt to discourage you. Some photographers persist, but some change their style or give up entirely after a while.

Galleries often ask photographers to come

Geometrie V.
© 1985 Beatrice Helg. Courtesy of Jane Corkin Gallery, Toronto.

© Eikoh Hosoe.
Courtesy of Light
Gallery, New York.

back several times before offering to exhibit their work; the galleries know that only a certain percentage of photographers will keep coming back. William Ewing, now an independent curator after working at the International Center of Photography (ICP) and for many international exhibitions, explains, "The competition will eventually lessen by sheer perseverance." Persevere if you believe you have something to offer. Gallery dealers who invest space, time, and money in you must be serious in order to keep their galleries alive. They expect the same level of commitment from you. How long should you persevere? However long your confidence and passion endure.

Photographers intent on presenting their work to galleries must be both dedicated and persistent. Fewer and fewer galleries accept unsolicited portfolios or have the time required to review the endless stacks of images that may be included in future exhibitions. Tennyson Schad, owner of New York's Light Gallery, explains, "When I am the slightest bit interested in the work, I'm going to want to assimilate it. I'm going to want to be able to look at it and think about it." And while collectors are increasing in number, they are not breaking down gallery doors. When making their selections, curators and dealers usually first ask themselves whether or not a contemporary

photographer's work is quality work. Schad points out:

> For the people who have great bodies of work, there are central ideas to each one of those great bodies. When you're presenting it, I want to see the central idea. People come into Light Gallery and say, "I've got some wonderful pictures of kids in Central Park, and I've got some wonderful photographs of. . . ." They're all over the place. And I say, "You're a snapper. You're just shooting pictures. There's no passion here. You're not obsessed with an idea." It would make it a lot easier on the other artists if you could get rid of the snappers, if you could say, "Listen, just hunker down in the corner, read *Popular Photography*, and make pictures for your own amusement and your family's."

Some gallery owners and directors use more certain criteria when they judge a portfolio. Both Michele Chomette of the Galerie Michele Chomette and Jean-Claude Lemagny of the Bibliothèque Nationale believe that the photographs should have a place in the history of photography. Lemagny maintains that the photographs should reflect the history of the art and continue its evolution. A strong graphic quality, a clear sense of composition, and good use of color are what Julie Saul and Nancy Lieberman of New York's Lieberman & Saul Gallery look for first.

Self-Portrait, 1978.
© Ellen Carey.
Courtesy of Eileen
and Michael Cohen.

ICP's Willis Hartshorn insists on photographs that are visually compelling. The images must reveal intelligence on the part of the photographers. Hartshorn explains:

> I am not interested in showing the work of somebody who is not going to be photographing in a year or two or three or four. And I'm also not interested in giving somebody a show ten minutes after they walk in the door. I want to know what kind of individuals they are, and I want to have a sense of how their work has developed. To do an exhibition requires a great deal of commitment on the part of the institution and curator. It's got to be reciprocal. I've got to feel that this is somebody who has that kind of investment in their activity as well.

Jeffrey Fraenkel, the owner of a San Francisco gallery, shares this view. He says, "Each photographer that we show requires a great deal of effort and attention on our part." Fraenkel continues, "Many contemporary photographers I've seen rarely work at a level that warrants the kind of commitment that we make toward the artists whom we choose to represent."

Galleries also often have strict guidelines for the form of the work they will accept for review. Light Gallery wants only prints, and the portfolio must be a representation of the photographer's most recent work. New York's Lieberman & Saul Gallery usually requires 16 × 20 prints; only photographers outside the United States may send slides. Gallery owner Michele Chomette prefers original prints, but will look at slides. Marge Neikrug of the Neikrug Gallery is more specific about submissions. The photographs should be uniform in size and should be Cibachrome or dye-transfer prints since the durability of C-prints is not guaranteed. In addition, the black-and-white images should be together, and the color images should be together.

Another important element gallery owners and directors must consider is the budget. How many shows can the gallery afford and in how much time? Salability enters the picture a lot more than any of us claiming rights to fine art care to discuss—but must. "There is so much to do, the selling of the work, exhibitions, publicity, paperwork, all the administrative work," explains Julie Saul of Lieberman & Saul, one of New York's newest private galleries. Evelyn Daitz, director of the Witkin Gallery, points out other expenses, such as rent, staff salaries, and taxes. Keep in mind, then, that the costs of running a photography gallery are prohibitive—in case you're thinking of opening one in order to show your work.

Stonehenge #1.
© 1976 Richard Misrach. Courtesy of Fraenkel Gallery.

PAYMENT AND PRICING

Photographers who want to remain photographers, remain photographers, spending most of their time as photographers and making most of their living as photographers, according to Agathe Gaillard, who owns a gallery and represents, among others, Bernard Faucon and Hervé Guibert. If the desire to take pictures becomes a personal, private satisfaction, your photography is a favorite hobby, not a profession. If you think that you cannot earn enough with your photography, you won't expend the energy required to do so, and you will not be able to do so. You will have to find another way to pay the rent. "If you play the loser, you will lose," Gaillard observes.

Nancy Wilson Pajic, an American photographer living in Paris who has exhibited at Michele Chomette's gallery, calls herself an artist, not a photographer. "I work in the concept of art, which gives me a perspective on photography," she explains. Pajic leaves the sale of her work to Chomette, who has arranged sales to both private and public collectors. "Who wants to run around looking for people to buy?" asks Pajic. She prefers to spend her time teaching, organizing workshops and films, and working on the personal photography proj-ects that provide most of her financial support. As Pajic sees it, "Sometimes it's dangerous to produce something somebody will buy. It pulls you off your track. Especially for those starting out."

Anyone harboring illusions of becoming an affluent noncommercial photographer will soon learn that this rarely happens. Although Steichen exhibited one of Joel-Peter Witkin's photographs when Witkin was seventeen, it took the photographer fourteen years to show another portfolio to New York's Museum of Modern Art. Photography curator John Szarkowski then purchased two images for the collection. Witkin is now enjoying widespread acclaim: Pace/MacGill in New York and Jeffrey Fraenkel in San Francisco represent him in the United States, and well-known collector and dealer Harry Lunn exhibited his work at the 1986 Mois de la Photo in Paris. But being "hot" often only means the security of a following, a reputation. "People get the impression that I'm wealthy," explains Witkin. "This is not true. My wife tattoos for a living. I work at least fifteen hours a day." Even so, Witkin is still passionate about his photography: "I throw away at least 60 percent of my prints because they are not perfect enough!"

New photographers will also find that the range of payment for their pictures is wide.

Cirque. © 1984
Nancy Wilson Pajic.

Most galleries take a 50 percent commission. But before you go to your darkroom to print, make sure that you have written, not just oral, agreements. There are also many variables involved in pricing photography. While the photography market indicates a growing interest in investments, some photographers inflate their optimism and their egos beyond logical limits. Well-known photographers, such as Eve Arnold, Henri Cartier-Bresson, and Robert Doisneau, can sometimes earn more than $1,000 for a 16 × 20 print. With auction prices, even the sky is not always the limit.

Former gallery owner Cortia Worth suggests the following guidelines. For a limited edition of eighteen prints, charge at least $300 for the first five prints, $900 for the next five prints, and $1,200 for the next five prints. Indicate "price upon request" for the last three available prints. This figure can exceed $5,000. Once this edition of eighteen is sold, no more prints should be available, unless the photographer, the dealer, and the collectors agree on a new limited edition in another size. (A negative is rarely destroyed, even for limited editions.)

A large number of variables affect pricing. The first is the photographer's background and experience. Has the photographer had work included in exhibitions or published? Has the photographer ever taught? Is the photographer on the workshop or lecture circuit? What are his or her associations with publications: reviews, articles, a column? Another consideration is the photographer's level of productivity. Pricing is also determined in part by how much the photographer's work is in demand and by the number of prints in the limited edition.

Gallery owner Marge Neikrug explains her pricing philosophy. "When I have a color exhibition, I sell," she says. "Some collectors purchase in-depth, black and white or color. I prefer the photographers exhibited in my gallery keep modest prices so that the average person has the opportunity to collect. The beauty, the richness of photography is the ability to make multiple prints." But Neikrug tells photographers, "Get what you can!"

The gallery wants you to succeed aesthetically and financially. Gallery directors who believe in you back up their judgment with an exhibition, which means an investment of both time and money. All parties involved hope to do considerably better than merely pay for the gallery's and the photographer's expenses. Although the potential for profit is there, you must remember that you are artists even if you categorize or separate yourselves as photographers. As Jean-Claude Lemagny of the Bibliothèque Nationale quickly reminded me, "In our society, art is very expensive. And the artists are always badly paid while their work is often

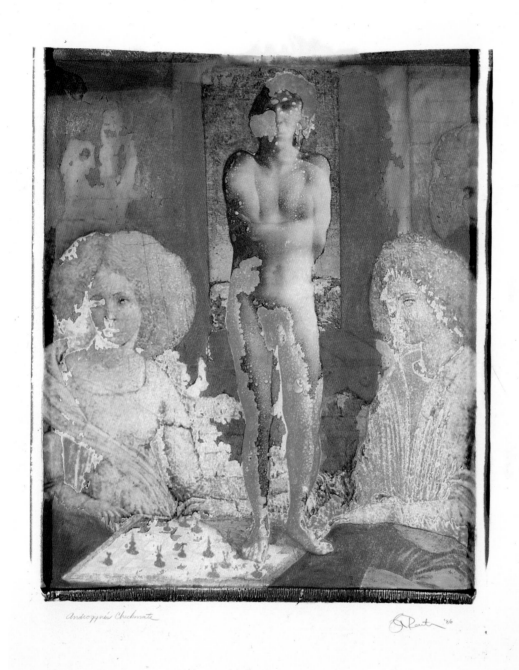

Androgyne's
Checkmate. © 1986
John Reuter.

The Work of Our
Hands. © 1987
Sandra Baker.
Courtesy of Neikrug
Gallery.

Nude with Egg.
© 1987 Will
Faller.

Columns, New York City, 1979. © Judith Turner.

© Ruth Mayerson
Gilbert. Courtesy of
Neikrug Gallery.

prohibitively expensive." The risk is to price yourself out of the market.

The gallery exhibition, then, falls into its proper perspective. It is a point, not an end point, but a point along the way. In all likelihood, it will not bring about a financial coup. Speaking for many other photographers, Nancy Wilson Pajic notes, "The show is not what the work is about. The show is when you finish something. The end of research. The best results. It is a satisfying part of it." Photographer Judith Turner, who has had exhibitions of her work in London, Tokyo, Israel, Paris, Holland, and New York, adds, "Shows don't change your life as much as you think they will." As Turner points out, it is the cumulative effect of cumulative efforts that moves you along. Jane Corkin, a Toronto gallery owner who represents Beatrice Helg, sums it up: "In terms of the business aspect, the show is not the most important thing. The show is really only one very small part of an artist's overall career."

MUSEUMS

© 1984 Mariana Cook.

I n the late 1970s significant photography was dispersed throughout various regions of the United States, far from New York's Museum of Modern Art (MOMA). Other museums, including the Minneapolis Institute of the Arts, Fort Worth's Amon Carter Museum, and the San Francisco Museum of Modern Art, have built first-rate photography collections. More centers are now emerging in Los Angeles, San Diego, Chicago, New Orleans, and Houston.

A noticeable difference exists among some of these museums, however. For example, in New York experimental photography is seen a great deal

while photography exhibited in the southern United States tends to be conservative work in both color and black and white, as Houston gallery owner Petra Benteler points out. The Center of Creative Photography in Tucson, Arizona, is a major force in contemporary photography in the Southwest. It is an important archive and research center devoted to the study of twentieth-century photography as an art form. In addition, each year a number of exhibitions are held in the Center's Contemporary Gallery featuring new work with a full range of color and black and white.

In France, museums are the primary collectors of photography. Françoise Marquet, curator of the Musée d'Art Moderne in Paris, buys a great deal of photography, including that of American photographers. The museum has purchased a number of Mariana Cook's photographs. However, only fairly well-established photographers can expect to rely on foreign museums to finance their next project.

Michele Chomette, owner of a private gallery in Paris, has a different view of museum exhibitions in France. "There is a lot of politics in the museums over photography," she observes. "So now and then, the museums give exhibitions of contemporary photography—alibis of exhibitions—in a little hallway in the back practically on the way to the restrooms." In the future, "when photography is really acquired by the conservateurs of the museums," Chomette contends, French museums "will find the space and the budget to do something really *vivant* on a high level." Unfortunately, contemporary art has been regarded this way for centuries.

It is true, however, that many curators in both France and the United States complain that what museums can do differs greatly from what they actually do, as do their actions and their words. Although most photographers share this view as well, they leave their portfolios with museums anyway: they have nothing to lose and much to gain.

SELECTED MUSEUMS

In the last twenty years, the photography market has become saturated with countless new photographers, their portfolios, and their images—held at their sides, traveling through the mail, or left at museums. Every photographer believes that his or her portfolio is special. As a result, many photographers complain that it is much tougher now to be discovered among the hordes. But an innovative, discerning curator or dealer can usually spot an exceptional photographer, deliver him or her from obscurity, and advance the artist's career through a network of collectors and a series of exhibitions.

Despite this possibility, submitting work for a critique is often disappointing. Most gallery directors feel overwhelmed and believe that the critique is the work of the museums, which are curators in a public service position. John Szarkowski, photography curator at New York's Museum of Modern Art, says that MOMA is:

> devoted to the function of the museum. This means, devotion to the collection and to trying to maintain an adequate record of what is the significant work that has come out of a medium during our time.

Szarkowski seems to diminish the powerful position he and his colleagues have in choosing the art for and supporting the museum's photography collection. "I find it impossible to believe," maintains Szarkowski, "that if this museum had not exhibited Arbus or Friedlander or Egelston at the time that it did, that that work would have remained unknown."

That Arbus' style would have attracted attention without MOMA there is no doubt. But MOMA's support, as well as that of other museums, enhances the reputation (not to mention the living conditions) of any artist, especially that of photographers, whose field needs as much institutional acknowledgment as it can get. According to Cortia Worth, former gallery owner and first vice president of the Association of International Photography Art Dealers, Inc., museums use only somewhere between 5 percent and 10 percent of their budgets for photography. Without more support from museums, legitimizing photography as a collectible art form is essentially left to galleries and collectors.

All of the museums listed here accept slides sent by mail if they are accompanied by a self-addressed, stamped envelope for the return of the material. Any additional information, such as the day a portfolio may be dropped off, is just a telephone call away.

THE MUSEUM OF MODERN ART

New York's Museum of Modern Art has a wide and varied collection of contemporary photography. Recently, MOMA began a series of shows supporting new photographers. The exhibition, entitled "New Photography," will be an annual fall event.

Submissions. The Museum of Modern Art looks for work done with "vitality, vigor, confidence, and panache." The photographs should reflect "a new aspect, a new sensibility, or a new element that changes, even subtly, our sense of what is possible in the medium." MOMA also wants work that it could not anticipate before seeing it. Finally, the museum prefers work that will persuade other photographers that there is something in the images to pay atten-

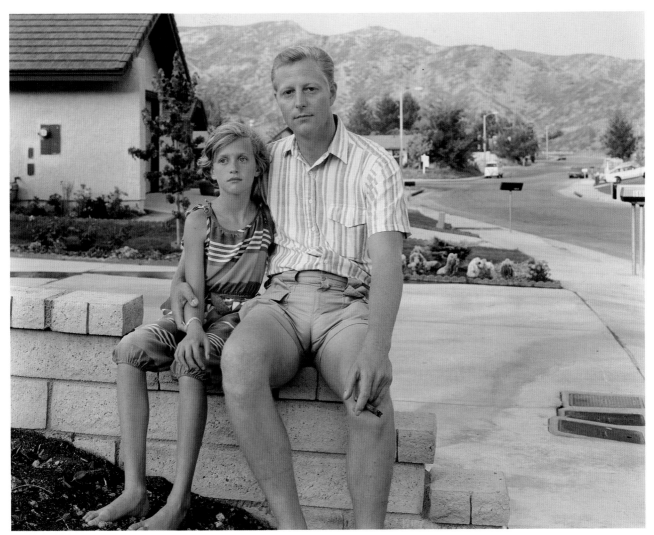

Canyon County,
California, July
1983. © Joel
Sternfeld. Courtesy
of The Museum of
Modern Art and
Pace/MacGill
Gallery, New York.

Table Study. © 1983
Zeke Berman.
Courtesy of
Lieberman & Saul,
New York.

She quickened with the realization
that things would never be the same.

Untitled: from Real
Life Dramas
1984–87. © Mary
Frey. Courtesy of
Ledel Gallery,
New York.

tion to, to learn from, and to use to expand their own sense of the medium.

Photography curator John Szarkowski explains the museum's payment policy:

> If we can afford it, we buy at the photographer's price range. We buy especially in the case of the young photographers, those whom we think are going to be good for a long time. Sometimes the photographers who want us to have two prints instead of one will throw one in or give us a discount which they would give to a dealer.

THE AMON CARTER MUSEUM OF AMERICAN ART

Founded in Fort Worth, Texas, in 1961, this museum has a sizable collection of photographs that represents, according to Carol Roark, assistant curator of the photography department, "the full range of American photography's history." The museum is interested in acquiring color and black-and-white images concerning only the United States or work by American photographers. The museum's collection, which currently consists of 250,000 prints and negatives, is purchased from dealers as well as individual photographers. The collection of contemporary photography is growing, and, says Roark, "We are making acquisitions all the time." The vintage and contemporary photographs are exhibited on a rotating basis.

Submissions. For both black-and-white and color work, photographers should send duplicate slides that are representative of their portfolios. Because of the problem with color stability, the museum prefers dye-transfer prints; it has, however, accepted some Ektacolor and Cibachrome prints.

Payment. The museum pays the photographers' established price for their work.

THE ART INSTITUTE OF CHICAGO

The photography department of the institute was created in 1983. The collection chronicles the history of photography and consists of approximately 15,000 photographs. These are shown in the institute's three photography galleries on a continuing basis; this arrangement allows the history's entire spectrum to be displayed. David Travis, curator of the photography department, and his staff are always looking for new, interesting work in order to increase the institute's collection of both vintage and contemporary work.

The Art Institute of Chicago has two vaults for the storage of the photographs, one for color work and one for black and white. The vaults' temperature and humidity levels are set to ensure optimal preservation of the photographs. However, the institute does not require dye-transfer or Cibachrome for color prints, believing that the materials chosen are a reflection of the individual photographer.

Submissions. The institute does not accept any unsolicited portfolios in the mail. It does, however, have a weekly portfolio drop on Tuesday mornings at ten o'clock. This drop is open to everyone, but the portfolios must be delivered. If you cannot do this yourself, send your portfolio to someone who can drop it off for you. Photographers are welcome to include a description of their work or of themselves with their portfolios. As do most other museums, the institute returns portfolios without any comments. It does, however, keep its notes on the photographers' work, which are updated with each submission.

Payment. The Art Institute determines payment on an individual basis. Some of the factors involved include: the number of prints requested, the extent of the edition, and the source of the photograph—dealer, collector, photographer, donor. The institute also differentiates between archival prints that never see the light of day and exhibition prints.

THE MUSÉE D'ART MODERNE

The Musée d'Art Moderne in Paris acquires and shows contemporary photography. Françoise Marquet, creator of the museum's photography department, is best known for her large retrospectives of such photographers as Alvarez Bravo and Jan Saudek.

Submissions. The Musée d'Art Moderne wants photographs that reflect universal human values and experience and teach us about ourselves. It also looks for photographs that show something never seen before, even in a classic photograph, such as a nude. Marquet prefers "photography which has the weight of poetry, such as landscapes which invite us to dream," and wants "portraits which show the interior of the portrait and leave us to imagine the universe of the portrait."

COLLECTORS

Dream Cord. © 1979 Frances Murray.

Jean-Claude Lemagny, curator of the Bibliothèque Nationale in Paris, one of the most complete photography collections in the world, believes photographs must be collected the way gravures—engravings, lithographs, etchings—are: in quantity. A photograph, like a gravure, enables multiples of the original to be made. More than one collector can then own a group of images that reflect an artist's evolution. This individual is a rare phenomenon known as *le vrai collectioneur*, the true collector. Such collectors are essential to galleries and fine-art photographers, especially those who rely on the income from a gallery or collector.

PUBLIC AND PRIVATE COLLECTORS

Public and private collectors are attracted to fine-art photography for various reasons. For some, there is the vintage photograph, a sound, blue-chip investment. For others, there is the pleasure of following trends or individuals and putting together an eclectic collection. For all, photography is the most accessible or affordable of the arts, whether the investment is made for profitable resale, for gaining recognition through amassing the work of one or more photographers, or for the sheer pleasure of having a complete collection of a study they love.

Private collectors, however, have an advantage over public collectors. John Szarkowski, photography curator of New York's Museum of Modern Art explains:

> While the public collector, such as a museum or library, is obligated to try to give some kind of coherent sketch map of the territory, a pri-

vate collector has no obligation to cover the field. They are rather dumb if they do. They have a responsibility to what they really like. If they don't really love it, they had better not buy it.

CORPORATE COLLECTORS

As anyone in any private business knows, most of the big money is in the pockets of corporations and banks.

Curators of corporate collections rarely buy just one photograph. They have a lot of space to cover and the necessary funds. As a result, having a corporation collect your work can make the difference in the funds you can use to buy your next roll of film. Although corporations and banks are not buying as much as photographers and dealers would like, the situation is steadily improving.

Helene Zucker Seeman, manager of the art program of the Prudential Insurance Company of America, radically changed the Prudential

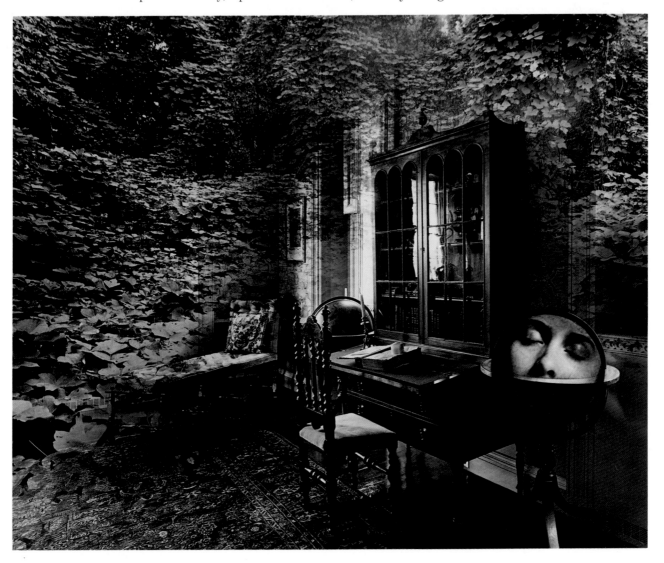

Untitled 1982. © 1982 Jerry N. Uelsmann. Courtesy of The Witkin Gallery, Inc., New York.

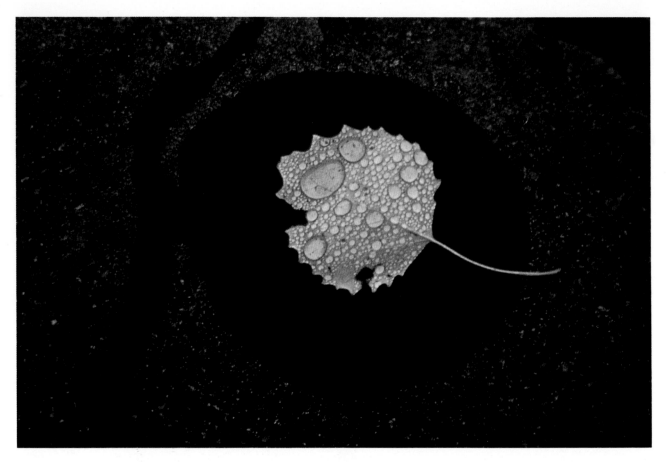

Life Insurance collection, one of the largest supporters of contemporary photography. Until several years ago, Prudential purchased very little photography because the company was "hesitant to purchase color because of the archival problem." Seeman explains:

> The work we buy is always hanging. Just because I hang it in a safe position away from direct light doesn't mean it is going to stay there. People move the images around. Prudential purchases color in the lower price range in case there are any archival problems.

Despite this potential drawback, Prudential continues to be a prominent collector. "We buy about fifty photographs of contemporary photography a year," adds Seeman. "We often buy in series, groups of work. We loan to museums all the time."

Joan Kravett, design coordinator of Smith, Barney, reveals the predicaments she and many other corporate directors of photographic acquisitions often face. First, not everyone considers photography to be fine art. "I decided to include photography to the dismay of a couple of people here," says Kravett. "I think it has a wonderful place in a corporate art collection because it is liked by almost everyone whether it's abstract work or representational work." Limited budgets are another potential problem.

At Smith, Barney, Kravett points out:

> We're not looking to spend thousands of dollars on an individual piece. We have ninety-five branches throughout the United States. Ten percent to 15 percent of our furniture budget is allotted to original paintings, prints, and photographs.

Nevertheless, she is pleased with the company's fine-art photography: "I like the variety of our photography collection, which includes black and white as well as color."

Corporations like Prudential Life Insurance and Smith, Barney are among the greatest collectors a gallery can work with. However, Cortia Worth, first vice president of the Association of International Photography Art Dealers (AIPAD), warns:

> If you ask these big corporations, they will talk about their commitment to fine-art photography, and they will talk about how much interest there is, etc. But if you ask them what percentage of their budget is actually spent on fine-art photography as opposed to fine art, you will find it's like the museums who are also giving a lot of lip service to photography. That bottom line, in fact, will be around 5 percent or 10 percent, if that much.

More often, and most unfortunately, Worth's description of photography as "the bastard child" of the art world rings true.

PHOTOGRAPHY: VINTAGE OR CONTEMPORARY?

According to gallery dealers and directors, most collectors today want vintage photography: the prestigious collection, the secure, wise investment. As Alain Sayag, curator of photography at the Georges Pompidou Museum in Paris, observes, a photography gallery can always stay in business by catering to the collector of vintage photography. Paris gallery owner Michele Chomette shows both vintage and contemporary photography. By selling vintage work, Chomette explains, she can afford the financial risks that come with showing contemporary photography.

Unfortunately, many collectors prefer not to risk a change and stick with a smart investment. Marge Neikrug, a New York gallery owner, says that for more than ten years, most collectors have been ready to invest in vintage photography. Ann Lapides, associate director of the Zabriskie Gallery, shares this view of collectors. "They may look at a few other things," she says, "but their collections are vintage."

Because many collectors prefer vintage photography, the curator who shows contemporary photography runs the greatest risk. But this decision offers the curator a challenging yet satisfying opportunity. Paris gallery owner Agathe Gaillard, whose eye for original contemporary photography is well known throughout the United States and Europe, explains:

> The existence of galleries and collectors can, in effect, stimulate personal creativity for those photographers whose work would not fit into the press or advertising. The gallery and collector offer the possibility of personal work which would only be of interest to the collector. This is a positive effect for the *vrais artistes* [true artists] to express themselves, such as Bernard Faucon. It permits them original creativity. There are always the originators and many followers.

The George Eastman House in Rochester, New York, was willing to take this risk and now has one of the most impressive collections of contemporary photography in the United States. Although it purchases work at the photographer's price, the real importance of the Eastman House is its exhibitions. "We have about eight or nine shows a year," says Mary Ann Fulton, associate curator of the photographic collection. "Once in a while, they are all contemporary; usually half of the exhibition is contemporary. We have a large show in the back four times a year with about 200 to 300 prints of contemporary work." And, as Fulton points out, "To have a show at Eastman House

Indirect Objects.
© 1987 Lorie Novak.
Courtesy of
Lieberman & Saul,
New York.

Burroughs as
Baudelaire. © 1953
Allen Ginsberg.
Courtesy of Miriam
and Ira D. Wallach
Division of Art,
Prints, &
Photographs, The
New York Public
Library.

has a certain amount of prestige because we see so much work and have relatively few shows [and] few spaces in which to be hung."

Julie Saul, co-owner with Nancy Lieberman of the Lieberman & Saul Gallery in New York, also has a refreshing yet realistic approach to collectors of fine-art photography:

> I would say that there are very few, five or six, serious collectors of photography. But we sell a lot to people who are sort of our contemporaries. I guess you could call them Yuppies in a sense, young professionals who are not perhaps interested in creating a huge photography collection but are interested in buying art.

The gallery's opinion of the photography itself is also refreshingly to the point. Saul says, "One of the reasons that we are such advocates of contemporary photography is that it is beautiful and important work. And it's affordable."

The New York Public Library is also starting to focus on contemporary photography. Julia Van Haaften, curator of photography in the Art Prints and Photographs division, says that until a couple of years ago, the collection was made up of photographers' donations. Now, however, the library has a budget for acquisitions. While contemporary photography is a new phenomenon for the library, Van Haaften enthusiastically confirms that contemporary photography is more affordable than vintage. In addition, if an image fosters interest in the New York area or other regions of the United States, other areas of the library's budget can be tapped. As a result, Van Haaften is able to acquire more contemporary photography.

Few people involved in fine-art photography—vintage or contemporary—share this enthusiasm. Some experts find most collectors to be followers of trends rather than connoisseurs of art. "It's like anything else, real estate in Southampton or in Soho," comments Cortia Worth, AIPAD first vice president. She says:

> In the case of photography, John Szarkowski could choose to put a particular photograph on the cover of a book. It may then be chosen by the *New York Times Magazine*. It's the validation of the people in the know, in power.

Such a consideration is not what really counts. As Worth points out, "In the end, it's how important the work is over the long run, how lasting is the imagery."

William A. Ewing, an independent dealer who has spent many years with Light Gallery, the International Center of Photography, and the Castelli Gallery, is "wary of collectors." He explains:

> They tend to be very cautious and are motivated to be safe and follow the currents dutifully. I'm not talking about the top collectors, because they can take very much a leadership role, someone like the late Sam Wagstaff or Paul Walter. I'm talking about the run-of-the-mill collector who buys what is required of him.

But if you can continue your investment in yourself, and increase your exposure, shy collectors are more likely to be motivated to purchase your work.

THE COLLECTOR'S SEARCH

Unlike "run-of-the-mill" collectors, Marjorie and Leonard Vernon of Los Angeles, California, have a varied collection based strictly on their own taste. "We've never bought anything that didn't have an aesthetic appeal to us," explains Leonard. "We've never bought anything because it was a good buy or an investment or because it was maybe nicer historically. If the photograph also said something to us, we would acquire it." The collector points out a change in the couple's acquisitions: "In the contemporary work, we're tending to look more towards color even though black and white has been our prime love."

Where do the Vernons look for photographs that will become part of their collection? "Any place and every place." Their search takes them to offices, galleries, museums, showrooms, and dealers. In addition, the Vernons are visited by people from all over the world.

Arnold Crane, one of the earliest brave collectors, recently sold his photography collection to the J. Paul Getty Museum. He describes how today's collectors must go about their search: "We, the collectors, have to be able to see the photographer's work on the wall somewhere or in a gallery lobby, then be able to say, 'This is a new genius. . . . I ought to buy them.'" Of course, collectors have more work to choose from now. As Crane points out, "There are a lot of closet photographers, figuratively and literally. But if you're good, somebody eventually sees your work." You should remember, too, that there are more collectors of photography now than ever before.

One of the greatest American collections of vintage photography was created by Pierre Appraxine for the Gilman Paper Company. Although he is interested in contemporary photography, Appraxine will not look for photography in galleries. He explains:

Galleries are not my favorite place to look at a photograph. You have the feeling that you are being solicited all the time. A photograph for me is something that you look at quietly. You have to have the time to scrutinize it. The photograph is a microcosm so you have to look closely. And I have a feeling that the pressure of the marketplace does not allow for that.

14th Street White Tower Hamburgers. © 1949 Robert Frank. Courtesy of Gilman Paper Co., New York.

At auctions, on the other hand, many collectors find that they can pick up more for less. Unfortunately, too many inexperienced collectors fall into the trap of overbidding only to end up with a poor-quality print. And, all auction sales must be taken "as is" and are final. But, as gallery owner Tennyson Schad says, "Auctions can present attractive buying opportunities for canny buyers. This is particularly true about the work of new photographers." One of the most exciting photography auctions is held on behalf of Camerawork, a San Francisco nonprofit gallery that offers diverse contemporary photography and related visual arts through exhibitions, lectures, and publications.

As Jean-Claude Lemagny notes, true collectors of vintage and contemporary photography do exactly what their name implies. They do not buy just one print for the living room; they follow a photographer's career. They collect.

Persona 2. © 1982 Judith Golden. Courtesy of Leonard and Marjorie Vernon.

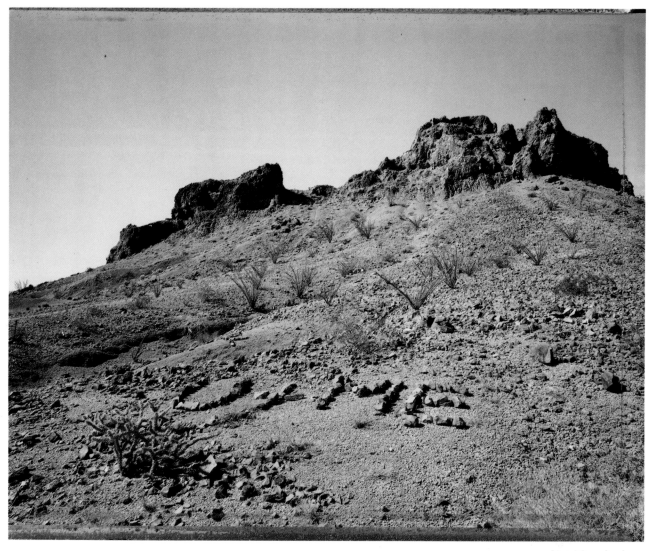

THE SEARCH ENDS

When collectors find a photographer's images exciting, they often make a serious commitment to the artist's work. Dealer and collector Harry Lunn's backing of a photographer he believes in is a good example of such a commitment. Shortly after 1975, anyone who wanted an original Ansel Adams, Diane Arbus, or Robert Frank had to buy one through Lunn; the collector would corner a particular market by buying out a photographer's work. When prices hit the ceiling, the artist as well as the status of collecting photography, of course, benefited. Later, believing in Joel-Peter Witkin's unusual eye and talent, Lunn brought a large collection of the photographer's work to Paris for the 1986 Mois de la Photo. As a result, Witkin attracted international attention.

Which photographers are collected most frequently outside the small circle of such exceptional collectors as Harry Lunn, Leonard and Marjorie Vernon, and Arnold Crane? Aside from vintage photographers, there doesn't seem to be a consensus. Independent dealer William A. Ewing explains:

> I've seen so many second-rate photographers pushed enough so that they start being gobbled up by the collecting machine and are, therefore, on kind of safe ground. And my heart screams, "No! Not this one!" There are so many arbitrary factors in who gets collected, who essentially gets pushed.

John Szarkowski, photography curator at the Museum of Modern Art, agrees: "The collector is human . . . capricious, at times naive."

Some collectors have very definite preferences. Although Joan Kravett, design coordinator at Smith, Barney, accepts both slides and prints, she has restrictions on their content. Kravett is interested only in images that evoke a positive feeling and are bold, strong, peaceful, and provocative, but not too bizarre. Helen Zucker Seeman, art program manager at the Prudential Insurance Company of America, buys creative images, but like most other corporate collectors, will not buy erotic photographs.

© 1983 Jan Groover.
Courtesy of
Prudential.

PAYMENT AND PRICING

Having a collector's support enables you to begin a financially sound career and to continue working in your own way. Collectors are most often found through gallery dealers. When collectors believe in and like your work, they will back up their appreciation with money; they keep galleries and photographers afloat. Of course, one collector's support does not a year's studio rent make, and one interested collector with an established reputation does not ensure that others will share this enthusiasm. The following advice should help you survive in the world of collectible photography.

Appearing to offer a photographer a glamorous life through increasing public interest and support, the photography market can be seductive. It can also be unpleasant. In 1969 one of the biggest—and few—collectors in the United States approached Aaron Siskind, one of photography's greatest innovators. The collector wanted to buy photographs spanning Siskind's career, which began in the 1930s. Siskind and the collector first agreed upon fifty black-and-white images at a price of $25 each and fifty others at $35 each, all 11 × 14 prints. Siskind did not realize, however, that he would have to chase the collector for payment. Unfortunately, Siskind had accepted an I.O.U. As a result, he had to pursue the collector for two years via telephone calls and letters; the photographer finally received his payment. Several years later, Siskind again went after this collector, who had made an immense profit on the photographer's work. Eventually, however, Siskind's images were exhibited throughout the United States and Europe and commanded much higher prices. As the saying goes, others often reap an artist's profits long before he does.

Photographers must be aware of the latest pricing standards and trends in order to protect themselves and their work. Auction fever often inflates prices for fine-art photographs to extremes. This can benefit both new and established photographers. As Light Gallery owner Tennyson Schad noted in his 1981 article, "Shooting from the Hip":

> It is that material otherwise unavailable that draws the auction crowds. Other master photographs, offered for sale in galleries throughout the country, may therefore be overlooked, and it is not uncommon to see fine examples going for low or wholesale prices.

Today the "newest and most exciting work," explains Schad, "is cheap, and it's plentiful. For each collector who is buying 20 or 30 prints, there are 500 to 1,000 prints by other photographers which are easily available." A 16 × 20 print of Mark Klett's U + Me sold for

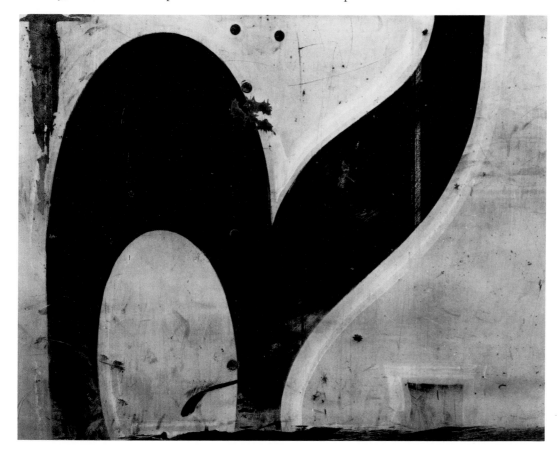

Chicago 1949. © 1949 Aaron Siskind.

$500 in 1985, while Naomi Weissmann's Three Quinces, a Cibachrome print, sold for $350 that same year.

The Association of International Photography Art Dealers (AIPAD) has certain guidelines that enable collectors to predict which photographers have the greatest investment potential. These are the extent to which the work has been published or exhibited, the attention of recognized critics, and the innovation, seriousness of intent, and consistency exhibited in a large quantity of prints.

Unfortunately, AIPAD reaches only a minuscule number of collectors. A well-known photographer may have to ask the same price an unknown photographer does. This is determined by numerous variables, including how and at what point in the photographer's career the work is placed on the market, and the photographer's affiliations.

LIMITED EDITIONS
In the early 1980s the prices for Ansel Adams images dropped dramatically. The idea of lim-

Silvia Krystel.
© Irina Ionesco.

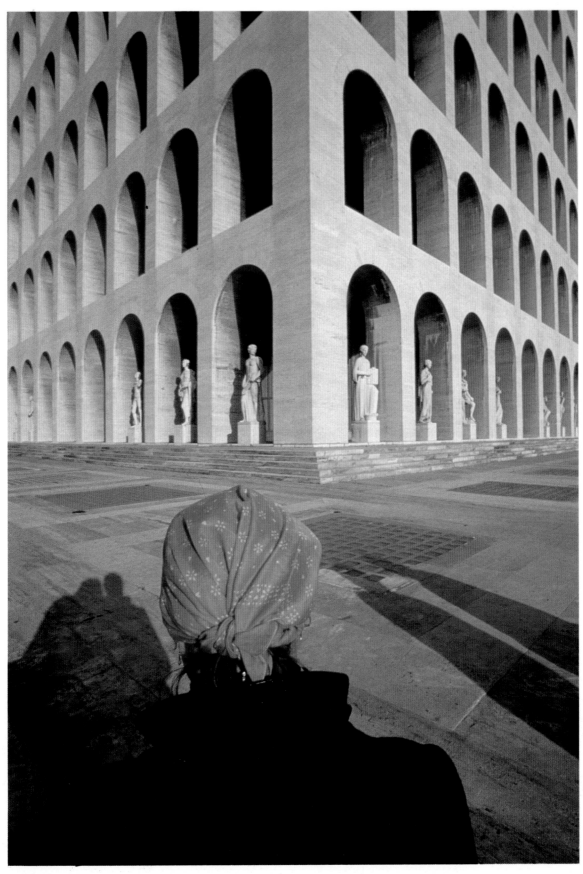

© 1979 Franco
Fontana.

ited editions quickly became popular. Today the question of limited editions comes up with every collection, large or small. Photographers must decide whether they want to sell few prints for large sums or many prints for smaller amounts. The number of prints in a limited edition is often dictated by the number of hours the photographer is willing to spend in the darkroom printing the same photo instead of moving on to another. On a more personal level, photographers must think about how much a particular image means to them.

Irina Ionesco, who has thirteen books, countless European exhibitions of her photographs, and numerous private and public collectors to her credit, states her uncompromising policy about limited editions:

> I never sell fifty editions of a photograph. My work of real importance, I sell three or four. I have others to show so I don't want a single image repeated infinitely. It will not have the same impact. I work a lot. I have a lot of images. One image could become famous of a sort, more than others if it's printed fifty times. But one must not demystify rarity. After I sell an image three or four times, I stop. I will propose it again for sale if I really love it, but images reproduced in large quantity no longer have the same value.

From the collector's point of view, limited editions can be enticing. Most collectors want to feel that they have something rare, which they share with just a few others. One way to ensure this is to buy a limited edition. "Built-in rarity makes the photograph collectible," observes Arnold Crane, one of the earliest collectors of photography.

An important element of this "rarity" is the photographs's price. Neale Albert, curator of the collection for Paul, Weiss, Rifkind, Wharton & Garrison, recommends—as a lawyer, advisor, and collector—that the price of a photograph be raised $100 for every edition of five. This automatically creates scarcity and makes the previous buyers happy that they got in on a better price. It suits the market and the photographer equally. In addition, Julie Saul of the Lieberman & Saul Gallery believes that the number of limited edition prints should not exceed 100. "We have really encouraged all of our artists to work in limited editions. And most of them are," she adds.

AIPAD executive Cortia Worth believes limited editions are "critical." She explains:

> Anyone who wants to have some entrée into the market, and I don't care what segment, whether it's color or dye transfer or black and white, I would advise anyone who is interested in having any marketability to limit their editions. There's a whole philosophy for not wanting to limit editions. But to me, this contradicts

good marketing sense for exceptional work. Limited editions encourage people to buy the work.

Collectors may want to purchase limited-edition prints, but not all of them are able to. As photographer Franco Fontana says, "Photographs are made to be popular, democratic." Gallery owner Marge Neikrug agrees: "It seems a shame that contemporary photography is not more available. Limiting editions contradicts the nature of photography, its richness."

Primarily, printing limited editions is a marketing question for each photographer to decide. The higher the number of prints, the lower the price. The lower the number of prints, the higher the price—and perhaps the fewer the buyers. An accurate assessment of your individual market is required, as well as the advice from your dealer. As Tennyson Schad reveals in "Shooting from the Hip":

> Instant rarity does not breathe life into the incipient market. Why? If buyers do not want the print at $150, they are unlikely to be persuaded to buy it at $350 simply because it is now limited in number. Limitation, if any, must follow demand, not precede it.

Photographers who must separate the passion for their art from their means of making a living, as Joel-Peter Witkin did, learn that reputable dealers act as liaisons between themselves and potential collectors. One established dealer (who asked to remain anonymous) says that he starts an individual "collector with a photographer whose work is fairly 'simple' with hopes that the collector will become real bored and come back wanting something more." This dealer attempts to train the collector's eye. Often, when people first show an interest in photography, dealers find that they want pretty pictures, "unless they are unique or come from a love of journalism."

The collector is cultivated, and in some instances coddled, by the gallery. According to AIPAD's directory for the collector:

> Most dealers will reserve a photograph while a client considers a purchase; many will extend credit; and some will even allow the client to take a photograph home on approval. When the client decides to sell all or part of a collection, dealers can also help by either repurchasing the work outright or by arranging to sell the work on consignment. Dealers are always concerned with maintaining a market for the work of artists they represent, and this concern benefits the collector.

Clearly a major source of support for the fine-art photographer—both financially and emotionally—is the collector. A collector has the potential to support the photographer adequately, substantially, perhaps even lucratively.

BOOKS

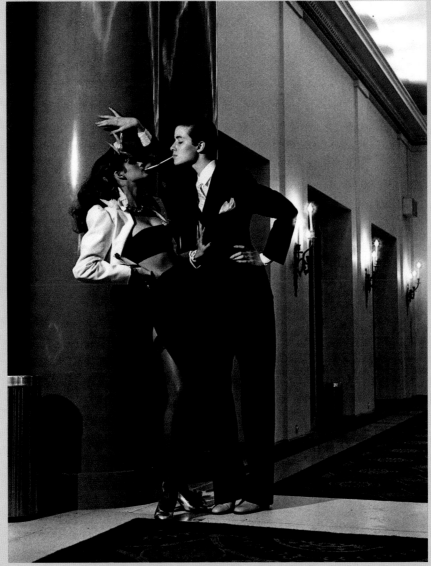

World Without Men. © 1985 Helmut Newton. Courtesy of Xavier Moreau, Inc.

Having your photographs reproduced well in a book is gratifying. Photographers are accustomed to seeing images on paper that has been treated and processed and get satisfaction from seeing work in printed form. As such, having photographs published in a book may seem ideal. Producing books is an expensive and often a lengthy process, however, and publishers want to be sure that each project is worth the investment. Consequently, it's difficult to get a publishing contract. Producing material for books also makes great demands on photographers; as Sonja Bullaty says, books are "a labor of love." And, adds Helmut

1928 Opel Race Car. © Andreas Feininger.

Newton, books will "never make you rich."

Andreas Feininger once called himself "a maker of picture books"; over a fifty-two-year period, forty-seven books of his work were published in the United States and Europe. The photographer worked on nine of these books with Dover Publications, Inc., a New York publisher that pays an author a flat fee rather than royalties. Feininger explains: "It is the joy of creating something new and useful and to explore new aspects of subjects that I am fascinated by."

WHAT A PUBLISHER LOOKS FOR

The marketability of a book is a primary concern for publishers. Unless there is enough interest in your name to sell enough copies of a book of your work—and to ensure that you will continue to receive royalties after the initial response—you must have a compelling subject. As any publisher will tell you, deciding on the subject or theme of your book deserves the utmost attention. Dan Green, chief executive officer of Weidenfeld & Nicolson, says that most people buy a book based on its subject rather than on the photographer's name or work. "If a subject is interesting, then you have to go through the portfolio and you have to say, 'Oh yes!' " Green explains. "There's no other way to do it."

Lauren Shakely, senior editor of art books at Rizzoli International Publications, Inc., points out, "So many people bring me portfolios that as pictures on the wall would be very interesting, but as a book are flat. Most bring me pictures and say, 'I want a book.' " Instead, Shakely advises, they should consider "which of these photographs would be the best for a book." She offers an example: "Margaret Courtney-Clarke is certainly a very fine photographer. She came to us with a specific project in mind." This gave the book a stronger appeal as well, a larger market, "which made it possible to produce a book that was all color."

Still, having a specific theme for a photography book does not ensure its success in the marketplace. A book featuring images of New York's Soho area came to Universe Books as a package. Senior editor Adele Ursone thought

Central Park
Celebrated. © Sonja
Bullaty. From *Circle
of Seasons*.

South Africa: Ndebele Mural Decoration by Leya Mahlangu, Wolwegat Farm, Verena District. © Margaret Courtney-Clarke.

that the photography was excellent and that the subject matter of the diverse and trendy Soho area warranted the publisher's attention. She now believes that the subject was too specific geographically. Ursone explains, "When I tried to sell it outside the New York area, the answer was, 'It's a New York book.' "

In a similar case, the editors at Abbeville Press were so pleased with the success of *Chelsea Hotel* that they decided to do another book with photographer Claudio Edinger, entitled *Venice Beach*. According to the publisher's director of business affairs, Mark McGowan, the same design format was used, and the second book's subject seemed more appealing. Nevertheless, the sales figures for *Venice Beach* are lower than those of *Chelsea Hotel*.

Many publishers, and most smaller ones, don't, unfortunately, have large budgets for publicity and promotion. To get around this problem, you must find a vehicle for your imagery that will allow your work to appeal to both devotees of photography and the general public, which is the larger market.

Robert Morton, director of special projects at Harry N. Abrams, Inc., says, "A book is a particular kind of creature, with a particular kind of life. You need to tell a story in a book. The book really has to be be about something." Publishers and readers are looking for something new, something to learn. Morton adds:

From the minute I entered publishing thirty years ago, photographers have come to me and they say, "I have a wonderful body of photographs, and my idea is that we get poems and pair them with each photograph." Every photographer invents this idea at some point. A book idea must be fresh.

POTENTIAL BOOK-PUBLISHING OBSTACLES

An obstacle to the publication of photography books rarely considered is censorship. In 1985 Eva Rubinstein's photographs of Lodz, Poland, were commissioned for a book by the Historical Museum of the City of Lodz. Two years later,

the Lodz police informed the publisher that the book was not to be published.

The amount of artistic control and input a photographer has is another possible problem. Photographers, like most authors, are rarely included in the production process. As Adele Ursone of Universe Books points out, "They don't realize that they will never be able to get the quality that they can get in the printing of the negatives." Photographers should be aware that their images can be separated and printed in only adequate style or printed on less than high quality paper.

Some publishers want and even encourage photographers to actively participate in the creation of their book; these publishing houses appreciate the photographers' help and understand their needs. "I can't have a photographer sitting on the shoulder of the designer day in and day out. But, on the other hand, in the selection of images and the sequencing of images, I want their input," says Robert Morton, special projects director at Abrams. "And I want their ideas on presentation." Abbeville Press, Inc., has extra page proofs made to accommodate its photographers. "Photographers are also trying to satisfy their sense of aesthetic and what a photograph should look like," explains Abbeville's Mark McGowan. Lauren Shakely of Rizzoli welcomes the opinion of any photographer "interested in the essential steps of creating the book." She finds that most photographers "have such good eyes and really can help in terms of color-proofing and that kind of thing." Although, as photographer Ralph Gibson points out. "you want as much control as you can possibly get," the publisher ultimately has the final say.

Distribution, which is crucial to a book's success, can sometimes be beyond the control of the photographer, a frustrating fact. When *Vermont in All Weathers*, a book by photographers Sonja Bullaty and Angelo Lomeo, was published, it was rarely available in Vermont. "We were told in a Vermont bookstore that they would love to have it," Bullaty recalls. "Three months later when we came back and asked how the book was selling, they said, 'What book? We never received it.' " Again, for reasons not always clear to photographers, the bookseller, the bookstore buyer, or the publisher makes the final decision.

Bookstore buyers may not be experts on photography, but they are experts on buying photography books. That is their profession, and their decisions largely determine the success or failure of a photography book. In general, bookstores buy what they think they can sell in the first few weeks of publication. "There is no raving market out there for photography

Cloister Window, Near Lodz, 1984. © 1986 Eva Rubinstein.

Sandi Fellman 1983

© 1983 Sandi
Fellman.

© Angelo Lomeo.
From *Vermont in
All Weathers.*

Philip Morris
Operations Center,
Richmond, Virginia,
1982. © 1982 Judith
Turner. From
*Annotations on
Ambiguity,*
published by Axis
Gallery, Tokyo,
1986.

books," explains Dan Green of Weidenfeld & Nicolson, a New York company.

According to distributors, the best target areas in the United States for photography books are New York City, especially Greenwich Village; Huntington Station, New York, which is on Long Island; Beverly Hills, Costa Mesa, and San Francisco, California; and Miami, Florida. Of course, wherever the book distribution takes place, any problems can be offset if your work is exhibited and receives good press.

Having a book of photography published is a lengthy and sometimes difficult experience. Photographer Judith Turner, who has had three books of her work published, explains: "Somehow with books, no matter how much time and effort one puts into them, there's always a few mistakes, and they really haunt me. It's very hard for me to overlook them." Well-known photographer Franco Fontana adds, "When the books come out badly, there is nothing you can do about it." Nevertheless, both photographers believe that a book is worthwhile. "I have put hundreds of hours into working on my books in addition to my exhibi-

tions. I do it because this is what I want to do," says Turner. Fontana feels even more strongly. "Books are my favorite because they stay," he explains. "They keep. They are a very important source for photography. And books are for everybody."

SELECTED BOOK PUBLISHERS

Because of the limited market for photography books, most publishers insist that the books appeal to other markets in order to meet costs. A strong subject is essential. Abrams, for example, recently released O. Winston Link's book about railroading, which is entitled *Steam, Steel & Stars.*

Many publishers believe that it is an honor to be published. These publishing houses offer small or no advances; the prestige they bestow upon the photographer is thought to be sufficient. As you consider whether or not to approach a particular publisher or to sign a contract, remember that satisfaction, not money, will probably be your biggest reward.

APERTURE

Aperture, the only United States publisher devoted exclusively to fine-art photography, has published more than 140 major works during the last twenty years. While Aperture is responsible for classic monographs, such as those of Edward Weston, Alfred Stieglitz, Ansel Adams, Lisette Model, and Dorothea Lange, one of Aperture's founders, it has also published the work of contemporary photographers, including Jan Saudek, Joel-Peter Witkin, and Neal Slavin.

Aperture takes plenty of risks. Director Michael Hoffman points out:

> The Diane Arbus project is an interesting example where no commercial publisher believed the book would be profitable, but Aperture, at first seeing the work, made an immediate commitment. Although, like much of the greatest work of our time, we doubted that it would find a large public at first, there

was no question of the eminence of Arbus' accomplishment and its significance.

Aperture is interested in new book projects of high quality from photographers all over the world. Andy Grundberg, photography critic for the *New York Times*, chose five Aperture books for a recent Christmas list, including Neal Slavin's *Britons*.

Submissions. Submit a body of work with text and background material. To be accepted, Hoffman says, "the work must strike me intellectually, emotionally, and visually."

Payment. Aperture pays advances that are "kept to reasonable amounts" to ensure that sufficient funds are available to maintain a high level of quality. Royalties are the primary payment, but they don't add up to much. According to Hoffman, the potential for future exhibitions and projects is another benefit.

Identical Twins, Roselle, New Jersey, 1966. Gelatin-silver print, 14¾″ × 14¼″. © Estate of Diane Arbus. Courtesy of the collection of The Museum of Modern Art, New York. Richard Avedon Fund.

Smithfield Market
Workers. © Neal
Slavin. Reproduced
from the book
Britons by Neal
Slavin.

CONTREJOUR

Contrejour is France's equivalent to Aperture. The house publishes only books of photography or books about photography, about seven titles each year. Contrejour has published books in conjunction with various museums, such as the Bibliothèque Nationale and the J. Paul Getty Museum, cultural centers, and companies, including Aperture, Fuji, and Kodak. They have shared distribution responsibilities, funding, and the pool of photographers. Although most famous for its editions of the masters, Contrejour also publishes new and contemporary photographers from all over the world.

THE NEW YORK GRAPHIC SOCIETY

According to Janet Bush, executive editor of the New York Graphic Society, now that the photography boom of the last decade seems to be over, "publishers have to be much more selective in what they publish as it is a good deal harder to market photography books." She continues, "Since the late 1970s, close to half of our list has been devoted to photography. We've kept up a fairly good number." The publisher has, however, been affected by rising production costs and, in turn, higher book prices.

Nevertheless, a majority of the New York Graphic Society's books are connected to some exhibition at the time of publication. The pub-

lisher takes on two or three contemporary photographers a year, "even if you're not Ansel Adams and yours is not a household name," explains Bush. "Most of the photographers whom we publish have been published before in magazines and have had exhibitions."

Submissions. Submit a written proposal explaining why you think your work would make a good book, and give some indication of what you think the market for the book would be. The body of work should be subject-oriented, reflecting a particular theme or a specific period in your career that makes sense as a book idea. Only send a retrospective if you're at the peak of your career. Be sure to include samples.

TWELVETREES PRESS

According to founder and director Jack Woody, Twelvetrees Press published its first book, by George Platt Lynes, because of its homoerotic subject. He explains: "The other publishers all wanted to clean it up, basically misrepresent the photographer. I felt it should be done right, so I did it myself." After six years of publishing only monographs, the company explains in the front of its 1986–1987 catalog how it survived and thrived: "The support of our artists, bookstores and the men and women worldwide who have chosen to purchase and collect Twelvetrees Press books are at the heart of our success."

© 1954 Aaron Siskind. From *Pleasures and Terrors of Levitation.*

Submissions. Submit between ten and fifteen slides or prints. Woody prefers black and white because he has yet to see anything of interest in color. Include a resumé to give a sense of yourself. But, as Woody points out, "It's the project we're interested in. We don't care whether or not [you] went to college."

Payment. Twelvetrees Press does not pay photographers an advance, but their work is magnificently represented and the distribution is strong.

GALLERIES

Another type of publisher contributing to the market of photography books is galleries. The Photography West Gallery in Carmel, California, for example, recently published Ruth Bernhard's *The Eternal Body*, a collection of fifty nudes, as well as Bret Weston's *A Personal Collection*. The collector's edition of Weston's book sells for $700 while the trade edition sells for $75. The collector's edition of Bernard's book sells for $400, and the hardcover trade edition costs $50. In addition to royalties, Bernard received an advance; this is not standard procedure. Carol Williams, director of the Photography West Gallery, is "committed to bringing photography to the public and making the public aware of just how beautiful these fine prints are." Although the cost of publication is "tremendously expensive," the Photography West Gallery supports its photographers in this very important fashion. Gallery exhibitions and gallery publications increase each other's chances of success.

In the Box.
© Ruth Bernhard.
Courtesy of
Photography West
Gallery.

Anjelica Huston,
Los Angeles. © 1983
Alice Springs. From
*Alice Springs,
Portraits.* Courtesy
of Twelvetrees Press.

SELF-PUBLISHING

Self-publishing is an alternative way to publish a book of your work. It is time-consuming, requiring countless trips to an expensive printer. It is demanding, choosing which photographs make the best book and arranging the most effective distribution network. But it can be lucrative and ensures you complete artistic control. Your relationship with your camera, however, is likely to suffer.

Photographer Ralph Gibson, dismayed by his lack of artistic control over two of his earliest books, decided to begin Lustrum Press in order to publish his own books of his images. He wanted complete control over reproduction quality, text, and presentation. As he explains, "It's a manufacturing business. There are a lot of unpredictables in trying to get a book to come out the way you want." As he says about *The Somnambulist*, "I didn't want to compromise it nor jeopardize it."

Photographer Beverly Pabst's photographs are touring the United States and are in private and public collections, including the Bibliothèque Nationale and Paris Musée Carnavalet. She approached Universe Books to distribute her book, *Paris Lights*, in the United States and Canada. She also went to France to find distribution in seven other European countries.

Pabst considers distribution to be key to successful self-publication. In addition, printing costs can vary greatly. "The printing in Italy saved me $5,000. Printing the book in the United States would have been twice what it cost in Italy," says Pabst.

The Enchanted Hand. © 1968 Ralph Gibson. From *The Somnambulist*.

Entryway. © Beverly Pabst. From *Paris Lights*.

MONOGRAPHS

Monographs are produced and distributed by publishing companies or photographers themselves. The audience for a monograph is usually limited to adoring fans, collectors, students, museums, and libraries. In order for a monograph to be a success, the photographer's name alone must be enough to sell the book.

The New York Graphic Society recently published a book of the work of John Pfahl, an established and respected photographer. The book is subject-oriented, a series of photographs that Pfahl took through picture windows. Clearly, a monograph can be based on a theme or a cohesive idea chosen by the photographer. Pfahl explains: "A book is primarily a means of communicating my work to a larger audience."

Although a monograph often "promotes print sales," as Pfahl points out, monographs are usually not very lucrative. The price of the book almost doesn't matter at the time of publication. The project is finished; the rest depends on the public. A photographer's monograph, for the most part, has a very specific—and narrow—audience. And, warns Robert Morton of Abrams:

> The audience for serious photography, both in the gallery and in the bookstore, is very small. And it doesn't seem to be growing demonstrably. Even Adams, Bresson, Kertesz have not always sold consistently.

An atypical monograph is photographer Larry Clark's *Tulsa*, which is about the drug subculture; the book's very existence put it in the public eye. "When the book was pulled from the shelves because of its court case," explains Gene Bourne, one of the owners of A Photographer's Place, a New York photography bookstore, "the price went way up, to the extent that a copy was sold at an auction for $800." *Tulsa*'s popularity continued, as Bourne notes, "When Mr. Clark republished it himself, it had become a cult classic and sold incredibly well." Riding on this success, Clark published his second book, *Teenage Lust*.

If you have an overwhelming desire to put together a book of your photographs, there is nothing more rewarding than to see it done well, either with a publisher or by yourself. If your body of work has a subject or theme, it will be much easier for you to find a publisher. But like the choices made by a gallery dealer, curator, or collector, those made by publishers are subjective. When you enter the world of book publishing, keep in mind that your book and the satisfaction that comes with it should be your goal, not monetary gains. Remember: the work is an extension of you.

© 1983 Larry Clark.
From *Teenage Lust*.

MAGAZINES

Polisario Dream. © 1984 Christine Spengler.

Most magazines are changing their formats to allow more room for photographs. The question for photographers is whether to set out to do fine-art photography or to tailor their work to the magazine market's needs. Unless you are Richard Avedon or Irving Penn, exclusively pursuing an editorial outlet for your photography is not likely to support you adequately. Photographers confined to the fine-art pages are not better paid or more frequently published than any other artists. However, just as a roll of film offers one potentially successful image after another, magazines can do the same if the photographs are reproduced well.

Magazines usually publish a series of images, which reflects a photographer's talent most accurately: a single, successful image—for a poster or card—can be considered a fluke. One good photograph does not a photographer make. Curators, collectors, and business and public relations experts look to magazines for a promising new show or photographer for an upcoming project. Bank and other company officials use magazines to find potential photographers for a brochure, book, or poster. Carol Williams, director of the Photography West Gallery, says, "We are not inviting photographers to send their portfolios, but encouraging them to get published. I am always looking in magazines to see who is being published." This is all the more reason to be sure your photographs are credited to you. This detail is "overlooked" all too often. (More information about photographers' rights can be found in the appendix and in *Professional Business Practices in Photography* by the American Society of Magazine Photographers.)

Magazines are the least expensive way to show a series of photographs to the largest possible audience. They reach more people than any exhibition does. All of this exposure only costs artists skill, talent, good work, discipline, and the willingness to look for the publication or editor that appreciates the nature of their work. For example, Diane Arbus began her career by working for *Esquire*. The magazine gave her both exposure and the freedom to explore her own style.

FINDING A SUBJECT AND STYLE

Photographers often shy away from personal subjects, but many editors, including Sonia Mahaim, artistic director of *Double Page*, prefer to see work that is highly individualized. Choosing a particular subject or point of view can make your work interesting, inspiring, and "focused." This reflection of yourself in your pictures can't help but to set your photography apart from the rest, making it unusual, unique, and publishable.

Christine Spengler, a photographer from Sygma, built her reputation primarily on her coverage of the warfare in Vietnam, Cambodia, Iran, El Salvador, Nicaragua, and Northern Ireland. Her photographs have been published by *Newsweek*, *Time*, *Paris-Match*, *Zoom*, and the Associated Press.

It is important that photographers do not allow themselves to be pigeonholed. Photographer Jay Maisel, for example, began his career shooting pharmaceutical advertisements for medical magazines. For years people thought that he did only pharmaceutical or medical

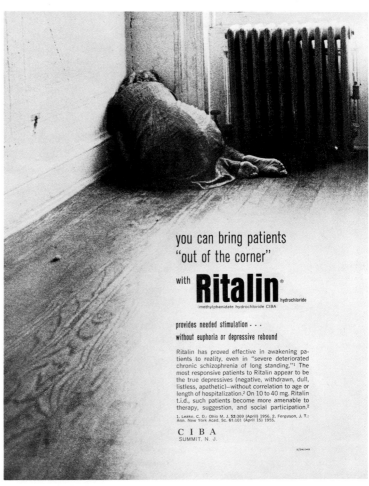

Photograph © Jay Maisel. Advertisement © CIBA.

photography. Maisel explains:

> Because the medical photographs were very dramatic, they won lots of awards. They were all about psychotic and neurotic patients, and the pictures got a lot of attention. People perceive you only in the way they've been exposed to you and based on their own predilection.

Maisel's association with other types of imagery—personal work, album covers, and jazz and dance photography—came about slowly.

Photographer Franco Fontana enjoys an ideal situation. His clients are already impressed with his work and give him carte blanche for their photographic assignments. This list of clients from all over the world includes *Vogue* (U.S.A.), Alitalia, the Bank of Kuwait, and Volkswagen.

There are a few problems, however, with the magazine market. The ever-increasing number of specialty magazines, such as those on tennis and golf, make it harder for photographers to have their work noticed or used. In addition, magazines devoted specifically to the subject of photography have changed radically. *Popular Photography*, for example, is now much more technically oriented.

Other drawbacks to photography magazines

© 1981 Franco
Fontana.

© Yvonne Vaar.

are their limited number and inaccessibility. Very few of them offer in-depth reviews of exhibitions or information about upcoming shows. Most of these magazines are published outside the United States because of the high cost of reproduction in this country. As a result, magazines such as Canada's *Photo Communique* and *Camera Canada*, France's *PHOTO*, and Italy's *Infinito* can be difficult to find and are more expensive than most in America.

Despite these problems, photographers find that, within the confines of the photography world, where an appreciation for the medium is already firmly established, magazines help their work get recognition. And, although publications based in different countries or cultures may want what others reject, good photography is seen, for the most part, as good photography. "Photography is a form of communication which doesn't need translators or interpreters," explains photographer Eva Rubinstein. "It is a universal language."

© Pete Turner.

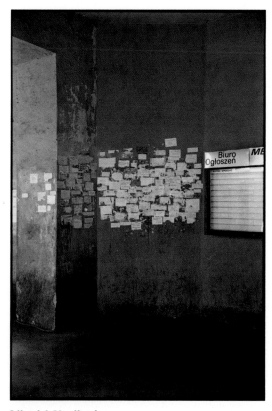

Official & Unofficial
Notices, Lodz, 1984.
© 1986 Eva
Rubinstein.

THE MAGAZINE MARKET

Presenting a body of work may seem easy, self-indulgent, and justifiable because of your passion for your images. But, in fact, it is one of the most demanding elements of stepping out of the commercial stream. Your portfolio must substantiate your private reasons in order to impress a magazine editor, to stand on its own, and to affect a world beyond you.

PHOTO
Written in French and distributed primarily in French-speaking countries, *PHOTO* must be sought out elsewhere, but it is worth the search, and the price. *PHOTO* addresses the general public while most other photography magazines are either technical in nature or are directed at the professional photographer. According to editorial director Michel Decron, "Forty percent of *PHOTO*'s readers are people who do not create photographic images with a passion. They are people who buy the magazine because the contents interest them." A "hard" or "soft" photograph of a woman usually appears on the cover of *PHOTO*, which attracts an audience that your work may not; the quantity of images printed gives the viewer a good idea of your style.

Rewards for reaching the general public through exposure in *PHOTO* can be lucrative and can come relatively quickly for photographers. This is the kind of exposure Franco Fontana speaks of: an agency or company looking for a photographer sees your fine-art images, wants you for its commercial assignments, and gives you carte blanche.

Presentation. An editorial team from *PHOTO* comes to the United States two or three times a year. Decron finds that New York is the capital for contacts. But, he adds, "We work just as well with the photographers we meet when we visit Chicago, California, and Florida when we are looking for new work to publish." Make an appointment to present your portfolio in person during one of these scheduled visits; you may want to include excerpts from other magazines in which your work has appeared. You can also have an agent or agency present your portfolio.

The editors at *PHOTO* sometimes choose to meet with photographers whose work they have seen at exhibitions or in other magazines, such as *Rolling Stone, Life, Interview*, and photography magazines. The editors also make contacts through certain agencies and agents.

Payment. PHOTO "has a tendency to pay less to those photographers who are very rich and a little more to those who have less."

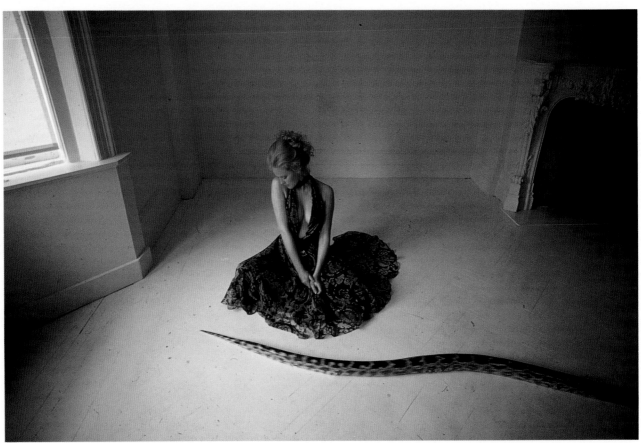

ZOOM

This magazine publishes famous photographers as well as many unknowns. *ZOOM* editor-in-chief Jacques Clayssen believes that showing a single image can be like making a great first impression. But through a collection of images, you are much more likely to be believed. As a result, your portfolio should be an accurate representation of your work.

Photography magazine editors often find themselves in the same position as the individual photographer. For the editor, as for the curator or collector, choosing photographs is personal and difficult to explain. "It can even be a question of disposition," adds Clayssen. "Something which would please me one day may not please another." He also reveals one of the hardest parts of his position:

> It is the public who determines the magazine, the contents. You must have sponsors to do exactly what you want. Everybody says not to use photographs *de charme* (semi- or entirely nude subjects, usually women) in photography magazines. But if not, nobody buys. The editors find the balance because photographs *de charme* are not the only photographs which sell the magazine.

Clayssen considers photography to be a cultural phenomenon. He says, "Since photographs are now in the museums, they are finally regarded as creators of another form of visual expression."

Presentation. Make an appointment to present your portfolio in person. You can also send your portfolio (never send originals) with pictures ranging from the family to abstract images.

Payment. For each page of work, photographers receive ten complimentary copies of the issue of *ZOOM* that contains their images.

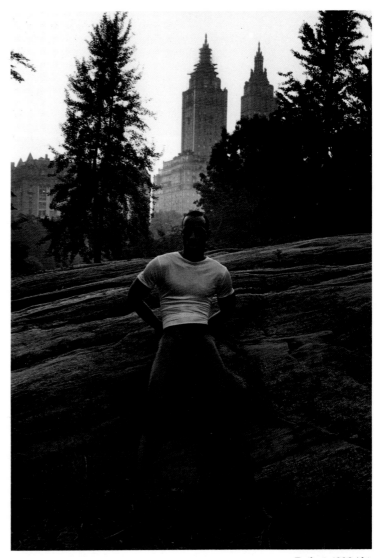

Park. © 1986 Aki Hirahata. From *ZOOM*, No. 122, 1986.

© 1981 David Goldes. From *ZOOM*, No. 122, French edition.

© Stephen Gan.
From *Photo
Magazine*.

PHOTO MAGAZINE

Photo Magazine (not to be confused with *PHOTO*) has a tremendous circulation with a highly innovative editorial policy. Less well-known photographers get equal billing on the magazine cover, and all of the photographers published are paid equally. Most important, *Photo Magazine* is always looking for new talent and is willing to take more risks than any other photography magazine.

The person responsible for this policy is editor-in-chief Jean-François Leroy. He works for the photographers he selects. When Leroy has felt that a photographer's images would make a better exhibition than magazine spread, he has contacted galleries and has arranged exhibitions. He also has timed exhibitions to run concurrently with the magazine's coverage of a particular artist and has arranged for some photographers work to be purchased by the Bibliothèque Nationale. "We do not content ourselves to just publish your photographs," Leroy says, speaking for himself and his staff, "and then never have anything to do with you."

Elaine Ellman, an American photographer published in *Photo Magazine*, describes her experience: "Jean-François Leroy is a photographer himself. He is knowledgeable and truly respects the medium. The layouts he proposed were dynamic, and our meetings were terrific exchanges of ideas between two colleagues."

Ellman realizes, however, that not all magazine photography editors work this way. To protect your photography, and your ego, she offers the following warning:

> Many editors understand photography only in terms of a kind of story line, and many are more interested in furthering their careers than in developing the aesthetics of their magazines. Photographers often try to second-guess these editors and end up fitting their work into a conventional magazine mold.

Adhere to your style, and think about your own career.

Presentation. Every Monday of every week, Leroy receives all those who wish to show their work. He wants to get a feeling for the photographers he may be working with and explains why he will or will not publish your images. Schedule an appointment well in advance.

Payment. Photographers receive approximately $100 per page and ten to twenty complimentary copies of the *Photo Magazine* issue that includes their work.

Room at the Top.
© Leigh Wiener.
Courtesy of The
Witkin Gallery, Inc.,
New York.

CAMERA INTERNATIONAL

Camera International looks more like a book than a magazine. Its production manager is Claude Nori, the renowned French black-and-white photographer. The magazine is published by Contrejour every three months in both French and English and is available in Europe, Japan, Australia, and the United States. *Camera International* primarily publishes established photographers—its editions can be packed with historical gold—and occasionally some less well-known photographers.

Presentation. Send a portfolio of duplicates of your best slides. If you prefer, make an appointment to present your portfolio in person.

Payment. Photographers receive 100 complimentary issues of *Camera International.*

AMERICAN PHOTOGRAPHER

American Photographer publishes classic images as well as the trendiest and most experimental types of imagery. Publication in this monthly magazine, therefore, does not depend on oversaturated nudes or images in which technique is the principal element.

American Photographer includes a "Portfolio" section that features four to eight images by new photographers. In addition, for the magazine's "Assignment" section, photographers can submit one 8 × 10 black-and-white photograph on such themes as "Child's Play" or "A Shore Thing," which are announced in each edition. With a circulation of 250,000, *American Photographer* is a great showcase. Associate editor Evelyn Roth reflects the sentiments of most gallery directors and publishers of photography magazines: "The photographs submitted must be interesting, exciting, at least not repetitive of what we have seen before." The audience plays an important part in determining whose work will be included. "It has to be material that they can grasp," explains Roth.

Presentation. Select at least ten but no more than twenty-five or thirty of your photographs. Put them in a cohesive group. Make an appointment to show your portfolio in person, or send duplicate slides.

Payment. The magazine pays $200 per page, and often only one image per page is used. Prices for cover shots are negotiated on an individual basis.

DOUBLE PAGE

Double Page is a photographic magazine that looks more like a glossy, oversized coffee-table book. While the focus of the magazine is often photographic studies of places from Yemen to the Mississippi, it is not strictly a collection of

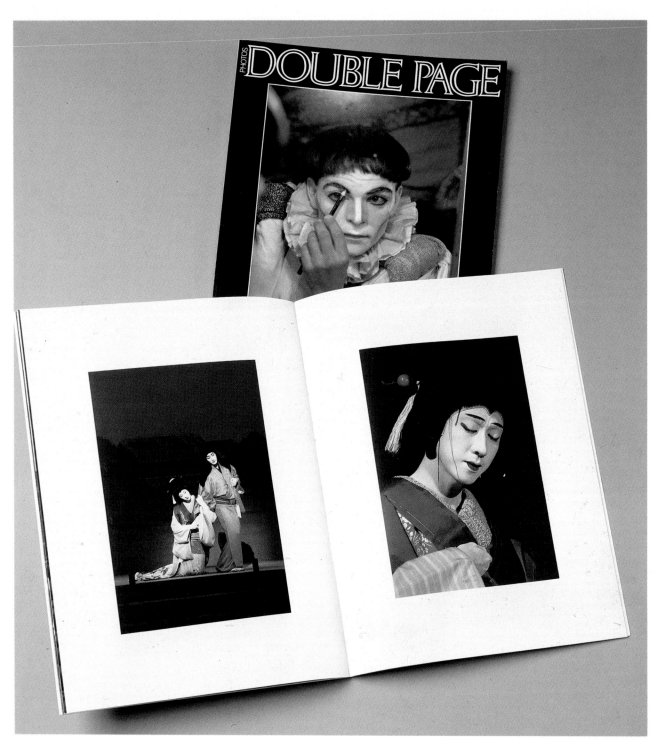

Cover photograph
© Martine Franck.
From *Double Page*,
No. 21, 1982. Inside
spread photographs
© Lyu Hanabusa.
From *Double Page*,
No. 13, 1981.

travel images. Its cover stories have included such subjects as street life, Shakespearean actors, and Kabuki.

Double Page publishes both well-known and lesser known photographers. The advantages to being published in the magazine are many. Its circulation is huge. In addition, *Double Page* is distributed by better bookstores and is often displayed on its own rack with many earlier editions, which are never out-of-date. The magazine is also collected. Perhaps most important is the amount of artistic control a photographer is given. According to artistic director Sonia Mahaim, the photographer makes the first choice of photographs to be used. After *Double Page* sees how they correspond to its artistic concept and how they tell a story without words, Mahaim makes the next selection. Any picture that the photographer does not want used is removed or replaced. At this point the photographer has not yet signed and can still take back the photographs. Once these discussions are finished, *Double Page* takes over.

Presentation. Double Page requires a minimum of 300 slides from which the magazine selects about twenty-five to thirty-two images. The work submitted must be original and must never have been or must never be used in a book or advertisement. Submit your work in person at *Double Page*'s office in Paris. You must also have original slides available for reproduction. You or your representative must be available to review the layout or copy.

Payment. The magazine pays a fee but asked that the specific amount not be disclosed.

PHOTO/DESIGN

Photo/Design is a slick, expensive magazine, complete with outstanding reproductions, excellent color, and high-quality paper. The magazine publishes portfolios that have already been produced for a commercial client. As such, the photographer has had to work within the confines of a budget and schedule and with a creative team: a client, an agent, an art director, a graphic designer, and an advertising director. The magazine's goal is to show how this creative team works together to ensure a project's success and to say something in a new way.

Patricia Goldstein, former editor-in-chief of *Photo/Design*, discusses some of the facts of the photography business:

> The marketplace is somewhat factionalized and at war between the agencies and the photographers and rates and buyouts and copyrights and all that craziness. But all involved share the common goal to create innovative and effective photographic images. That is the nature of the beast. Everybody wants the job to turn out well.

The ninth issue of *Photo/Design* includes photographs by Steichen, Horst, Hurrell, and Scavullo. Michael Going's impressionistic Polaroid images are also featured. As a result of this presentation, Going received a call from Frito-Lay. The company bought nine 30 × 30 Cibachromes for its corporate art collection, which includes a large representation of contemporary artists. Going was also given free rein on his assignment to cover the U.S. Open after his appearance in *Photo/Design*. "It's not the money that spells success," Going says. "It's the exposure's results."

Presentation. Photo/Design requires that the photographs submitted have been used in a commercial project. Submit photographs, slides, or tear sheets.

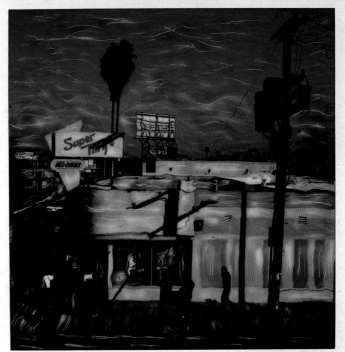

Superthrift.
© Michael Going.
Superthrift Melrose
Series.

Julian Beck. © 1985
Nam June Paik.
Courtesy of Holly
Solomon Gallery.

APERTURE

Aperture offers an alternative to the commercial nature of many photography magazines. One of its editors, Mark Holborn, explains that the magazine looks for photographs that "say something rather than photographs which are comments on photography." While each issue is thematically self-contained, the editors respond to the photographs that they see, then come up with an idea that they want to project. They look at work that "will support the argument," adds Holborn, "or fit into the issue." Because of its freedom from commercial control, this is a magazine for those whose work is way off the beaten track. As such, Holborn states, he and the other editors select photographs from a pool of the "greatest possible work in the world." But because of this very freedom, *Aperture* cannot afford to pay its photographers. Having your work included in the magazine is, however, invaluable.

Aperture is a quarterly magazine with a circulation of about 12,000 and an impeccable reputation. It is distributed in many English-speaking and European countries, as well as Australia and Japan. Since the magazine is funded by the National Endowment for the Arts and by subscriptions, its integrity need never be compromised.

Presentation. Mail submissions to the New York office, or make an appointment to present the work. The images presented must have a "coherent identity." Prints are acceptable.

Payment. The magazine does not pay for photographs.

TRAVEL MAGAZINES

There is yet another part of the magazine market for photographers that transcends the world of photography. These magazines, such as *Smithsonian* and *Travel & Leisure*, have tremendous circulations and depend on photographs to explore their subject matter. Not all of the photography is done by staff photographers. Readers of these magazines are tired of seeing the same photograph of the same monkey sitting on top of the same Jeep.

Chris Collins had a photograph published in 1986 in *Travel & Leisure* for a story on New York City. The picture was later selected by *American Photographer* as one of the year's ten best magazine photographs.

For those photographers straddling the line between fine-art and commercial, private, and functional photography, various magazine editors may or may not want the type of photography you have to offer. The choice is yours.

World Trade Center. © Chris Collins. Courtesy of The Stock Market of New York.

CARDS

Forget-Me-Nots and Window. © Harold Davis. Courtesy of The New York Graphic Society.

Cards, whether postcards or greeting cards, are a great way to get your images seen by people who might not otherwise see them. In addition, you don't have to travel with an exhibition of your work; the cards can travel for you. Any concern you may have about artistic control can be eliminated by checking a publisher's track record with other, more experienced photographers.

Although payment for cards has never made any photographer rich, you will find that cards can be a worthwhile venture when a number of your photographs are published and their royalties start coming in regularly. If it

La Geode, Parc de
la Villette, Paris.
© Bernard Faucon.

seems that the royalties will be meager, arrange for a good advance. Ralph Gibson works with several companies and earns between $4,000 and $5,000 a year from sales to the card market. "I may have fifteen or twenty images with Editions Mille (a French publisher)," he explains, "but four or five of those are really supporting the rest which aren't selling. You never know what is going to sell in what country." Bernard Faucon, one of France's most exciting contemporary photographers, expresses the sentiment of many photographers whose images are published on cards: "It may not be a tremendous amount of money, but it's steady." And all steady income helps support your work.

Photographic greeting cards are in greatest demand for the following events: birthdays, Christmas, Valentine's Day, Easter, and Mother's Day. Humorous images for all occasions are also popular. As such, card companies are always looking for new pictures. However, Bevan Davies, owner of Untitled II, a New York shop devoted exclusively to photographic and artistic cards and books, cautions, "Photographic cards are more faddish than anything else. We sell thousands of an image in one month and then cannot sell it the next."

Photographic postcards have an increasingly strong pull in the card market. Some people collect photographs by buying postcard reproductions. Some send only cards with the trendiest color photography, while others buy only black-and-white images. There are postcard "galleries" or shops throughout Europe; this type of store is catching on more and more in the United States.

Postcards offer other advantages as well. If your work is being exhibited, the cards can act as another means of publicity. Postcards are also a great way to gain exposure at a publisher's expense. If you have a book published (a project that, like most other photographic endeavors, will not support your lab fees by itself), postcards can be used to promote the book, increase your visibility, and, together with the book, support your photography. Ira and Judy Rheingold, two successful photographer's representatives, explain how they select their clients: "The postcard image must hit on an intellectual and an emotional level in the sense that it may capture a moment in one's life. The consumer must feel an identification with the image."

The card-buying public has an enormous and unpredictable range of tastes as well as a variety of needs. As a photographer, then, you can choose your own interests and shoot in your own inimitable way. There will always be a card market; you merely have to find a publisher or publish your own work.

David Byrne.
© 1983 Robert
Mapplethorpe.

SELECTED CARD PUBLISHERS

A photographic image can be striking and can still lose its strength in small format. Not all work can translate into or be sold as a postcard. Card publishers are the survivors of the "hit or miss" process of image selection, often the predictors of trends, and the promoters of their photographers.

FOTOFOLIO

With thirteen years of experience, Juliette Galant and Martin Bondell, Fotofolio's founders, have a clear sense of what kind of images can be reproduced in postcard format and still attract an audience.

The public, according to Galant, prefers images that, in general, are graphic, recognizable, or funny. Most people buy postcards because they are attracted to the image, not because they recognize the photographer's name. Fotofolio is publishing more color images than ever, but continues with its specialty: black-and-white images for note cards and postcards. Galant admits, "We do publish a lot of work that we know won't be best-sellers as postcards. We publish it because we think the work is important or because we like it very much and feel it should be seen."

Finally, through Fotofolio's international distribution, Galant has found that "Europe's market is much greater because postcards are more important" there than they are in the United States. The reason? Europeans write much more frequently than they call because their telephone system is so expensive.

Presentation. Fotofolio reviews pictures on a monthly basis. Send duplicate slides or prints. You can, if you wish, send photocopies of black-and-white prints. Be sure to enclose a self-addressed, stamped envelope for the return of your pictures.

Payment. Fotofolio bases its fees on the full quantity of postcards printed. For note cards, royalty fees are based on a percentage of sales. Photographers are paid within two months of publication.

CHROMALINE

Stephen Hender, who founded Chromaline in 1979, stresses a basic fact about card publishing: in order for you to be commercially successful, a certain base population must support what you see. If you take a series of photographs in the woods on an autumn day that evoke the crisp smell in the air and the sound of the wind rustling through the leaves—but only for you—nobody will buy or even publish them.

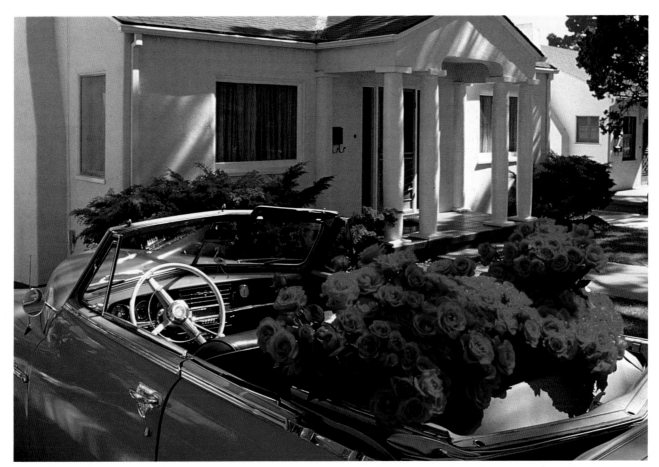

Hender insists on images that tell the story of "someone who's been there, someone who is going to be there, something that's just happened, something that's going to happen." He also finds that people can be attracted to simply beautiful or unusual images. Whether the idea is superficial or serious, a fine-art image must elicit some emotion without being sentimental or trivial.

Hender looks for potential photographers in magazines and books, and at exhibitions and such agencies as Image Bank and Magnum. Hender buys eighteen to twenty-four images a year for cards and is always looking for poster images as well.

Presentation. Chromaline sends sample cards or a brochure to photographers so that they will be familiar with its editorial viewpoints. Submit duplicate slides even if the originals are negatives. The images should be clean and direct, but subtle. The images should also be composed simply.

Payment. For its customary first printing of 20,000 cards, Chromaline pays an advance and a royalty fee, usually 5 percent to 7 percent of sales. Chromaline usually asks for a three-year contract.

NOUVELLES IMAGES

Nouvelles Images, which publishes some of the finest posters in Europe, also has a line of cards. Jacques Blanc is one to take risks. He believes in good photography and publishes it. He adds, however, that postcards with images that are "hard, severe, or a little sad do not sell." People who buy ten postcards buy them to send and want cheerful images, not pictures of a cemetery on a rainy day or an old woman carrying a pail.

Nouvelles Images distributes throughout Europe, the United States, Japan, Australia, Canada, and most of the rest of the world. It has only been publishing photographic posters and postcards, using superb reproduction quality, for the last five of its thirty years. "But now," says Blanc, "I have discovered a world which has captured my interest and passion."

Presentation. Send duplicate slides or prints or good photocopies to the Paris office. Although Nouvelles Images now has an office in New York, any work sent there will merely be forwarded to Paris for review.

Payment. Nouvelles Images pays photographers its standard advance immediately upon publication as well as royalties.

EDITIONS MILLE

Editions Mille is another renowned French firm that publishes postcards as well as posters. According to François Portelette, Editions Mille's artistic director, postcard images "must be very readable since they are purchased to represent the sender." Although postcards make a profit of pennies, they sell by the thousands: after all, they are the least expensive way to send a message through the mail.

Presentation. Submit prints or duplicate slides.

Payment. Editions Mille pays a guarantee and royalties upon publication.

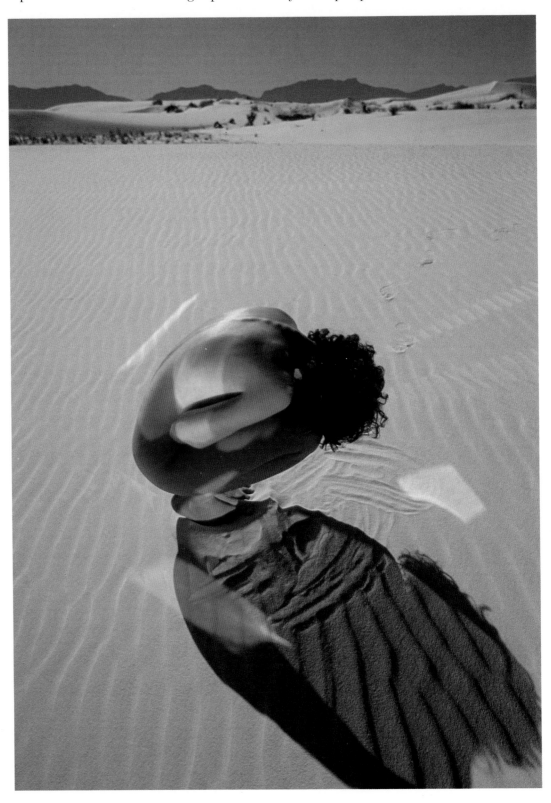

CATCH PUBLISHING

Based in Utrecht, Holland, Catch Publishing distributes its postcards worldwide, and its reproduction quality is among the best available. Peter van den Brink, founder and director of Catch, prefers photographers "with a good, solid reputation—those who have a series to offer rather than just one image." He explains the company's selection process: "One out of four cards has to really sell to make the whole thing possible. The other three are photographs which simply merit being published." The firm has published such photographers as Eva Rubinstein, Lilo Raymond, and Stephen Hender.

Presentation. Send representative samples of your work, in either slide or print form. These can range from four images to a complete portfolio. Be prepared to meet van den Brink at one of the annual international photography conventions in New York, Paris, or Arles should he notify you that he wants to see your complete portfolio.

Payment. Catch pays an advance and royalties.

BADIACO

Badiaco, yet another French publisher of posters and cards, distributes color postcards worldwide. Badiaco invests in its photographers. It rarely publishes a single image; it prefers to publish several to show a photographer's style.

Presentation. Submit real or abstract images with strong color. Send duplicate slides, or make an appointment, at least one month in advance, to present your portfolio in person to Abner Bagdahdi.

Paperbags. © 1982
Lilo Raymond.

© Nicola Wittum.

SELF-PUBLISHING

Self-publishing is expensive and time-consuming and can be very frustrating. The charge for printing 10,000 cards using six images can range from $15,000 to $20,000. As Jered Holmes, the owner of Click Productions, points out, however, the real problem is "not so much the money, but the time spent taking care of such matters as shipping, invoices, and record keeping." In addition, you may shoot great photographs but may not know which market they will succeed best in.

If you want to spend more time with your camera than in the marketplace, you may find that you need to hire a representative or "rep," often known in this business as a "reptile." When Stephen Hender, the founder of Chromaline, first started out, he chose reps who specialized in going to bookstores and galleries geared to his type of photography. As Hender says, "A Hallmark rep couldn't give them away." Reps may pull out some of your cards as well as those of their other clients in the hour or so they have to show their lines. Because buyers want to make as much money as possible for their stores, the smallest companies offer the smallest commissions, have the smallest chance of success, and get the least amount of attention.

What, then, are the advantages of self-publishing? Having direct control both of the reproduction and printing quality of your images and of overhead expenses.

PALM PRESS

Palm Press was founded in 1982 by Liz Bordow, primarily to publish her own images. Today, with a tremendous distribution in the United States as well as Japan and Canada, Bordow is buying 100 photographic images a year. Of these images, 99 are in color; the company's list of photographers includes Judy Dater and Richard Misrach. But with successful self-publishing comes a new set of burdens. "You have to choose," she explains. "To self-publish and expand means a business. And like any successful business, you have books to keep and all the rest of it. If you are a photographer, you are a photographer."

Palm Press' note-card market is targeted to

© Liz Bordow.

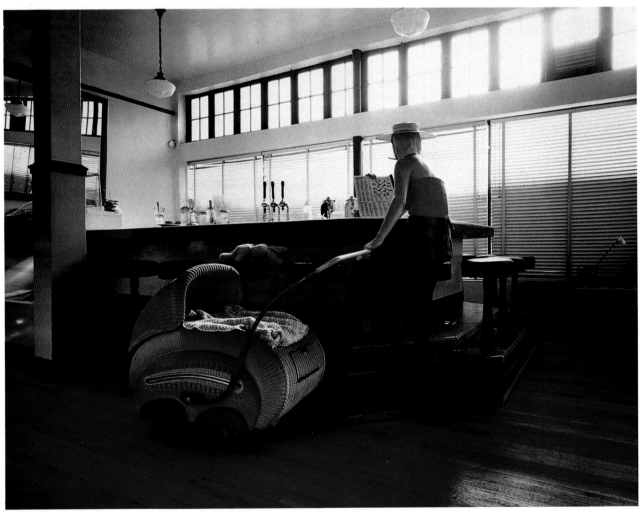

sophisticated audiences on the East and West Coasts of America. The first print run of a card is 5,000 copies, and the firm's business is increasing. Bordow adds, "Palm Press' audience is unlimited, while only a limited number of people can get to a gallery exhibition."

Presentation. Palm Press accepts duplicate slides or prints from anywhere in the world. Be sure to include a self-addressed, stamped envelope for the return of your art. Send humorous images or unusual graphic images. If submitting a concept for cards with copy, send photographs reflecting the theme.

CLICK PRODUCTIONS
Click Productions is a note-card company that was started by Jered Holmes, a soap-opera actor and an original member of the Broadway cast of *42nd Street*, with just $1,500 and fifteen cards. "The printing bills were over $25,000 to $30,000 every time we printed," he recalls. He needed to get loans to cover the mounting bills. "It costs $3,000 more for color correction. And . . . everything has to be the best—the best paper, the best envelope, varnished twice. You could wash our cards."

Holmes began selling his pastel photographs as blank cards to Bloomingdale's and Macy's, signing and entitling each one. The department stores bought his images for Christmas sales. This translated into 7,000 cards a year, straight sales, and no royalties. The stores dictate to the card companies. When they ask for new images, the card companies present them. But, as Holmes points out, this kills the shelf life of current stock since a company is given a limited amount of space in each store. The smaller your company, the less power you have. The trick is to get so big that you are in demand. (Some smaller companies are opting for buyouts by larger ones, who offer images from several different companies on an "all or none" basis.) Today Click Productions has 12,000 images and 200 regularly selling note cards and is worth $600,000.

Presentation. Send only images that move you or that elicit immediate responses from others. According to Holmes, if there isn't a word, an emotional range, or a feeling evoked by your image, you don't have a card. Submit duplicate slides.

Payment. Click Productions pays an advance of $250 plus royalties.

THE NEW YORK STATIONERY SHOW
Jered Holmes, the owner of Click Productions, highly recommends the annual New York Stationery Show at the Javits Convention Center.

Arrange for your own booth or share one. While at the show, scout out competitors. Although it costs a lot of money to display your work at the show, reps will tell you on the spot whether or not they are interested in what you have to offer. You can also get a sense of public reaction.

THE CALIFORNIA MUSEUM OF PHOTOGRAPHY CARD SHOW
On an annual basis, from December 10 to January 4, the California Museum of Photography displays holiday cards that use any type of photographic process. After the show, the cards are placed in the museum's archives.

Presentation. Send your greeting cards to Deborah Klochko, Museum of Photography, University of California, Riverside, California 92521.

Lillies. © 1987 Jered Holmes.

CALENDARS

CAPE LIGHT

1988 CALENDAR · COLOR PHOTOGRAPHS BY JOEL MEYEROWITZ

© Joel Meyerowitz. Calendar courtesy of The New York Graphic Society.

Calendars are a great vehicle for photographers with twelve or thirteen images on a single subject or theme. They enable your work to reach a widely dispersed audience—on an annual basis—that may have otherwise seemed inaccessible. Calendars, however, must have mass appeal. This does not leave much room for fine-art photography. Most calendar publishers insist that the photographs used be a cohesive collection, not merely an aesthetically appealing assortment.

A calendar is, without a doubt, a commercial venture. Calendar production is an expensive process when the photographs are reproduced well. The

profit potential, however, is great. As a result, the market is glutted with photographers who believe that their portfolios contain the images for *the* definitive calendar, if not for a dozen calendars.

Although the calendar market has exploded, there are some difficulties. The amount of competition is enormous and always increasing. Also, members of the calendar-buying public, for the most part, are considered relatively unenlightened about fine art. Easy to please, all most want from a calendar are the days of the year and amusing, soothing, or enticing pictures to look at. They want something pleasant, not something that assaults their imaginations or makes them think. In 1986 the best-selling photography calendars for the Waldenbooks chain included the *Sports Illustrated* swimsuit calendar (number two) and calendars featuring cats and kittens (number eight), teddy bears (number ten), and lingerie-clad women (number twelve).

Most bookstores don't want to give up the space set aside for a best-selling "sure thing," such as calendars featuring sailboats or teddy bears, for a risky item. According to Janet Bush, editor at the New York Graphic Society, which publishes calendars based on many of its authors' books, "The big chains have a hard time with new ideas." Nevertheless, the New York Graphic Society nudged its way on to the "sure thing" racks in 1986 and 1987 with photographer Joel Meyerowitz's Cape Light calendar. The twelve images were reprinted from the book of the same title, which had been a big seller in the northeastern United States and had won the American Society of Magazine Photographers Ansel Adams Award for Book Photography in 1985. The New York Graphic Society distributed the calendar regionally and published a 1987 edition with twelve other images from *Cape Light*. Almost all 30,000 copies of this edition were sold before Christmas.

Meyerowitz points out that a calendar may not lead to any future sales or assignments. Because a calendar requires a great deal of work and does not come with any guarantees, you must love the project for itself. Meyerowitz, who has no representative, card, or portfolio, adds, "Good work and a brown paper bag will get you anywhere you need to go."

SELECTED CALENDAR PUBLISHERS

UNIVERSE

Universe, one of the largest calendar publishers in the United States, puts out only two photog-

© Pete Turner. Calendar courtesy of Universe.

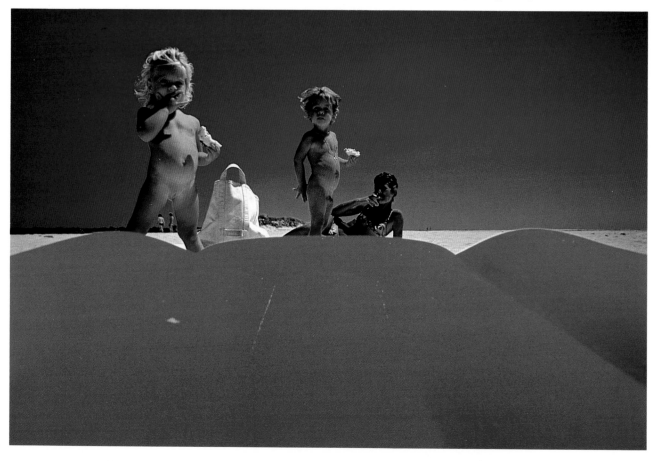

raphy calendars that sell reliably every year. The subjects of these popular calendars: food and sailing. In addition, however, Universe took the risk of publishing the Photography '87 calendar, which was composed of Pete Turner's images. The calendar was reproduced in conjunction with the International Center of Photography (ICP), a nonprofit organization. "Photography calendars are not easy to sell, especially when there is no subject of the calendar except photography itself," explains Universe senior editor Adele Ursone. In spite of its expected limited appeal, the Photography '87 calendar enjoyed a large national distribution.

Presentation. Submit a collection of slides or prints from an exhibition affiliated with an institution, such as ICP, a museum, or a private gallery, if the calendars can be displayed and sold there.

TE NEUES PUBLISHING COMPANY

Although "sure thing" calendars saturate the picture, the te Neues Publishing Company has twice published calendars featuring photographer Reinhart Wolf's images. The first calendar was based on his best-selling book, *New York*. The 1988 China calendar is also breathtaking. In addition, te Neues' reproduction quality and paper stock are superior. The China calendar had a 20,000-copy print run and was published in two editions, a four-language edition for sale in Europe and an English-language edition for

sale in the United States. As a result, Wolf's work benefited from international exposure in bookstores and department stores, as well as gift and museum shops.

Te Neues has also published a calendar featuring works by Edward Steichen in the collection of the International Museum at the George Eastman House.

Presentation. Submit an idea for a calendar in writing. Include references to your exhibitions and collectors: te Neues publishes only established photographers whose work is collected by museums. If you receive a positive response from te Neues, send duplicates of twelve images to be used in the proposed calendar. They must be museum-quality photographs, "in league with Reinhart Wolf," says owner Hendrik te Neues.

Payment. The te Neues Publishing Company pays an advance and royalties.

LANDMARK PUBLISHERS

Landmark Publishers puts out a tremendous number of photography calendars; these are among the company's better sellers. It searches for pictures at stock houses and exhibitions throughout the United States and Europe. The first print run of a calendar is usually 5,000 copies and distribution is worldwide.

Presentation. Submit an idea for a calendar in writing. Include a series of images that corre-

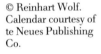

© Reinhart Wolf. Calendar courtesy of te Neues Publishing Co.

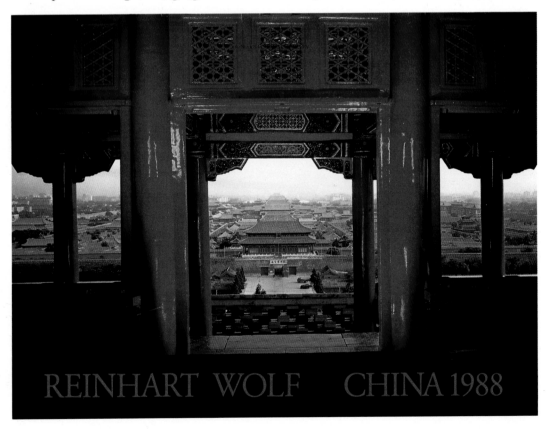

REINHART WOLF CHINA 1988

spond to or illustrate your idea. Landmark looks for clean images or still-life studies that show imagination. Do not send original prints or slides.

Payment. Landmark Publishers pays an advance and royalties if the calendar includes the work of just one artist. The company pays a flat fee per image if the calendar features a collection of images by various photographers.

HARRY N. ABRAMS, INC.

In 1987 Harry N. Abrams, Inc., published a calendar featuring Toshi Otsuki's photographs of New York's Central Park. The calendar was produced in conjunction with the Central Park Conservancy, which receives a royalty from sales. Taking a risk with the limited interest in the park, Abrams distributed the 20,000 copies of the calendar throughout the United States. Paul Gottlieb, president and editor-in-chief, agrees with the commonly held view that a calendar that includes photography must transcend the photography itself.

Gottlieb adds that the importance of the photographer cannot be overlooked. As a photographer, Otsuki has been obsessed with Central Park for more than twelve years. He had a major role in designing the calendar, right down to the captions; this rarely happens. "I have a responsibility as a photographer to Central Park," explains Otsuki. Why a calendar? "It is difficult to tell about a photographer from just one photograph," he says. Overall he was delighted with the results. Otsuki was especially pleased when he received calls from people in Boston, Massachusetts, and other cities wanting to buy his work.

Presentation. Although Abrams primarily publishes calendars based on its authors' books, you can send a letter with your idea.

Payment. Abrams pays an advance and royalties upon acceptance.

POMEGRANATE

Pomegranate, one of the leading calendar publishers in the United States, published eighty-six calendars for 1988. It is always looking for new ideas along with new photographers. The company gives photographers a great deal of artistic control. Pomegranate puts together a prospectus for its clients and reps, as well as its photographers. The prospectus includes the calendar's cover and miniatures of the images used in the calendar, all printed on high-quality paper. If a photographer is not pleased with the results, he or she can make changes. This level of artistic control is rare. And, editor Katherine Burke says that as of yet none of the company's photographers has been unhappy.

Among Pomegranate's many satisfied photographers is Stephen Shore. The twenty-four pictures used in two successive editions, in 1986 and 1987, of his calendar, The Gardens of Giverny, were taken from his book of the same title. With Pomegranate's well-known quality, Shore was not worried about artistic control. When he saw the company's presentation, he accepted its offer. Shore received a "reasonable guarantee" and royalty payment. The photographer was pleased with the results even though the calendar had no dramatic effect on his career. As Shore points out, serious collectors see his work in galleries, such as the Fraenkel Gallery in San Francisco, or in his book, *The Gardens of Giverny.*

Presentation. Send a letter of inquiry first. If you receive a favorable reply, send slides and a complete written version of your idea's theme.

Payment. Abrams pays an advance upon acceptance and royalties.

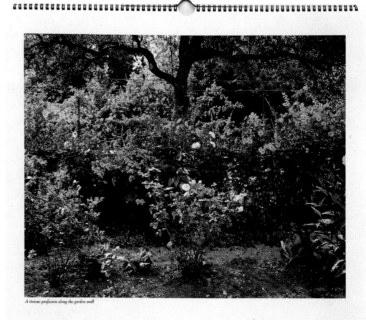

A riotous profusion along the garden wall

SEPTEMBER

S	M	T	W	T	F	S
		1	2	3	4	5
6	7	8	9	10	11	12
13	14	15	16	17	18	19
20	21	22	23	24	25	26
27	28	29	30			

© Stephen Shore. Calendar courtesy of Pomegranate.

© Willard Clay.
Courtesy of
Corporate Art
Directions.

ILFORD

Ilford distributes its calendar free of charge to its customers, which include professional photographers, other patrons of custom labs and retail shops, government labs, and corporations. In addition, Ilford distributes between 30,000 and 40,000 copies of the calendar worldwide, which is produced in seven different languages.

For the most part, Ilford seeks out "world-class photographers from any country," explains Bill Geizendanner, director of marketing and planning services for the company. The photographers usually are well known and work with high-quality black and white. Some of the photographers published in Ilford's calendars include Bill Brandt, Jean-Loup Sieff, and Franco Fontana. Geizendanner adds, "We choose the photographer in the first instance, and the theme follows on from that."

Presentation. Although Ilford ordinarily publishes established professionals, all photographers can submit ideas.

Payment. Ilford's contract price for photographers is a "nominal fee," a onetime, "mutually negotiated payment."

CALENDAR DISTRIBUTORS

Randy Rosenzweig, merchandise manager at Scribner's bookstore on New York's Fifth Avenue, points out that some best-selling calendars, such as the Audubon Society and Sierra Club calendars, use photography. Another photography calendar whose popularity is unfaltering—and unsurprising—is the Ansel Adams calendar. Rosenzweig says that each year Scribner's sells 25 percent more Adams calendars than the store is given initially. An amateur photographer profits from this popularity in several ways. The more Ansel Adams, Audubon Society, and Sierra Club calendars hanging in homes, the more people may consider collecting original photography.

Other major bookstores report that the Ansel Adams calendar is a big seller. At Waldenbooks, the Adams calendar is on the 1987 best-seller list of calendars (number eleven), while sales of the Sierra Club calendar have dropped off (number fourteen). But for nature photographers, there is always a calendar market. This genre can find a regional, national, or commercial publisher fairly easily. Willard Clay, whose unusual photograph appeared in the 1986 Sierra Club calendar, sold at least a dozen Cibachromes of the image as a result.

Jan Wood, director of marketing for the B. Dalton chain, explains the importance of regional distribution of photography calendars. Small publishers within each state produce calendars using photographs from the area. These calendars can leave more room for the photographer's imagination than you might think. This depends, however, on the region and the editor. Northland Publishers, for example, publishes *Montana* magazine as well as a calendar featuring photographs of Montana. California's New Sage Publishing puts out the Pasadena History calendar. Each region has potential and potential photographers. As it does with fine-art photography books, the public still buys photography calendars according to subject. At Scribner's most customers prefer "quality outdoor photography," according to Rosenzweig. Landmark calendars appeal primarily to a more specialized market that appreciates the offbeat photography the company publishes. "Those who are buying the calendar for the photography are the same people who are buying the monograph rather than a book of art history," adds Rosenzweig.

Photographers can always find their own markets. Ralph Gibson put together the American Civil Liberties Union calendar in 1969. Although he was approached by the calendar's designer, most associations or companies put together a calendar to distribute to their members or clients. Make yourself indispensable. Show your personal brand of fine art. This will enable you to find a niche that nobody else can fill. As a result, your collection of twelve images will be unique. Be prepared, however, to be rejected more often than not if your name doesn't sell itself or if your photography isn't the kind that can amuse, soothe, or entice someone for the twelve months of the year.

POSTERS

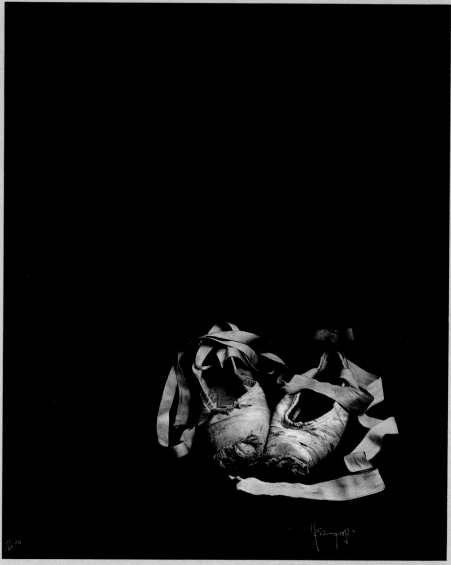

Ballet Slippers. © Harvey Edwards.

A poster is a photograph reproduced, most frequently, in a 30 × 40 format. The first print run is usually between 2,000 and 5,000 copies. If you have an image that you would like to see published in an unlimited edition and widely distributed without any cost to you (except patience while waiting for royalty checks), a poster sale is for you. The poster market is basically divided into three groups: fine-art posters; commercial-art posters, such as cars and movie stars; and commercial posters, designed for strong aesthetic appeal. Many publishers of photography deal primarily with pseudo-fine-art posters, which feature

Battery Park. © 1982
Louis Stettner.

eye-catching photographs that are designed to fit into most modern home-decorating plans.

Fine-art photographs for posters can be images that are simply attractive or distracting or images that offer the viewer something more profound. Harvey Edwards, one of the pioneers of photographic posters, shuns society's fascination with superficiality. Most famous for his images of dance, Edwards explains, "I see more beauty in old shoes than in a pair of new shoes. The new shoes know nothing about dance. The old shoes can say, 'I've danced and danced and danced.' " Through sheer perseverance, the photographer was able to establish himself via self-publishing. Edwards also opened the door for other photographers interested in this art form.

A poster publisher's decision to invest in a particular type of fine-art photograph is ultimately a personal choice based on individual taste, intuition, and an awareness of the market. Reproducing photography well, in large format and large editions, is an expensive process. A photographer rarely finds a gallery director who, like Carol Williams of the Photography West Gallery in Carmel, California, publishes posters of a photographer's work that is selling exceptionally well in her gallery. For the most part, publishing companies have the knowledge and capital to finance a good reproduction of a photographer's work. They must also distribute the poster wisely so that everyone involved, especially the photographer, profits from this joint creative venture.

Photographers can also benefit from the ar-

tistic control they have to exercise when one of their images is printed as a poster. To ensure excellent reproduction quality, photographers should check posters that the company has already published. They can also request to see a picture proof of their image. Another important advantage: publishers offer photographers the opportunity to see their images as posters without the headache of distribution and reproduction entanglements.

Because of the important role personal preferences play in poster publishing, some firms take great risks because of their belief in talent. Abner Bagdahdi is the owner and director of one such company, Badiaco. A Paris publisher of posters and postcards, Badiaco distributes them internationally and has high expenses. Bagdahdi recently invested in Italian photographer Nicola Wittum. Although Wittum's posters are exquisite and have the high-gloss, sharp-contrast look of a handmade Cibachrome, Badiaco is sitting with 4,000 of the 5,000 copies. The image had all the marks of a winner: strong color, decorative, abstract enough to provoke the imagination, and yet realistic. Why didn't it sell? Apparently people didn't understand the picture. As Bagdahdi explains, the photograph "is neither entirely abstract nor entirely realistic." Bagdahdi found that people can live with an unreal abstract image, but a rooted abstraction is too taxing. Viewers are caught between the mood and the reality of the photograph.

According to Pierre Brochet of Flammarion, a renowned French publisher, interest in ab-

Brett Weston
A Personal Selection

Photography West Graphics
Carmel•California

© 1984 Brett Weston, Dune, Oceano

stract images is growing, but they are still difficult to sell. The abstract images Flammarion is publishing are black and white. Brochet says, "We have published color photographs, but they just don't sell as well as black and white."

How important is the publication of a poster to a photographer's career? François Portelette, president of the French publisher Editions Mille, explains that while photography magazines help to establish a photographer in the world of photography, most of the people who buy the magazines and see a photographer's work are already interested in photography. On the whole, photography magazines don't introduce a photographer to the general public. The publicity offered by a poster, Portelette points out, "is essential for building a career, which is something other than working photographer, fashion, or advertising. The general public buys books, cards, posters, eventually prints." Portelette adds that the general public is beginning to see photography as an art form. "There is no reason for there not to be a market for photography," he says. "There is a market for drawings and painting. It is the problem of the vendor to organize sales."

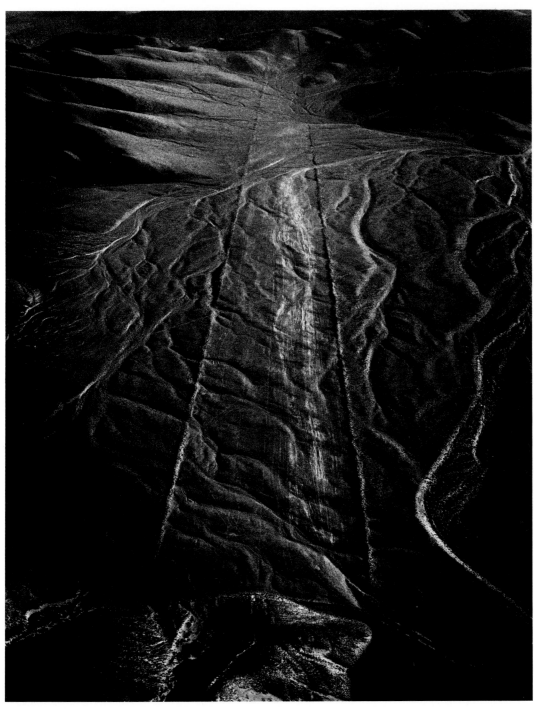

Pathway to Infinity, Nazca, Peru. © 1979 Marilyn Bridges. Courtesy of Editions Mille.

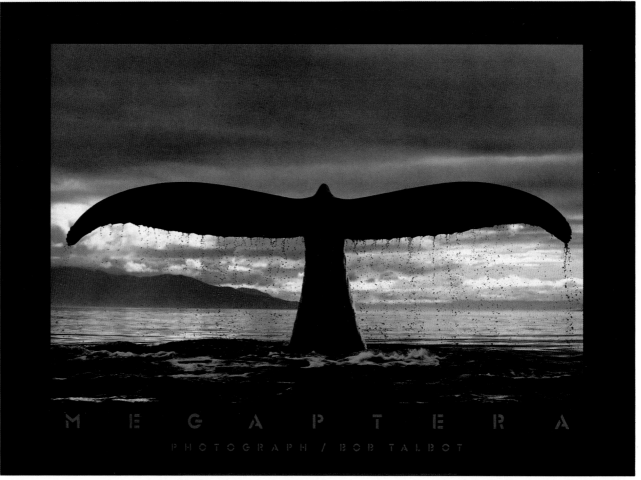

MEGAPTERA
PHOTOGRAPH / BOB TALBOT

Photograph © Bob
Talbot. Poster
© 1987 Mirage
Editions, Inc.

SELECTED POSTER PUBLISHERS

MIRAGE EDITIONS

Mirage Editions, located in Santa Monica, California, prints fine-art and pseudo-fine-art photographic posters. Owner Karl Bornstein also has a gallery in Los Angeles, which is now a great location for visibility. Two spectacular museums of modern art recently opened there, the Los Angeles County Museum of Art and the Museum of Contemporary Art.

Bornstein advises that unless an image is to be published as a poster, it doesn't make any sense to work in unlimited editions, printing as many as you can sell. Photographers should differentiate between the photographs to be printed as posters, in an unlimited edition, and those that will be numbered and signed. "You should have the confidence that you will be coming up with more great work," he explains.

In 1986 Mirage Editions published twenty-five new posters. Bornstein looks for "magical," and indefinable, elements in a photograph. If he finds them, the photograph may be printed in an edition of 5,000 posters—a staggering

notion. But a successful poster may result in the company printing 85,000 more copies.

Presentation. Mirage Editions welcomes the work of photographers from anywhere in the world. If Bornstein likes your work, he asks you for more material. If he then decides to publish your work, he meets with you, usually in Santa Monica. He prefers to buy pictures in a series, with a minimum of four. But if there is a special, "magical" image, Bornstein publishes it as a single poster. The company distributes all of its posters internationally.

Payment. Mirage Editions pays an advance and royalties.

BRUCE McGAW GRAPHICS

Bruce McGaw Graphics, whose first print run of an image is 3,000 copies, buys approximately twenty-five photographs each year for its posters. Paul Liptak, director of acquisitions, feels that Harvey Edwards' Leg Warmers image best represents what the company looks for in a poster photograph. The publisher offers the Leg Warmers poster for $30 and a limited edition of 299 Cibachromes of Leg Warmers for $600 each.

At Bruce McGaw Graphics, the photogra-

pher makes the final decision about the poster's design. Edwards explains, "I choose the paper and I do the separations. Others just submit the image and get a package of posters." Photographers also benefit from the company's promotion of its new pieces. It uses magazine advertising, shows the poster throughout its catalog, and holds special sales. As Liptak points out, viewer response is sometimes unpredictable. "There are images which you think are winners, and the response is very mediocre," he says. "Then there are those which you think are just horrible, and they are top-selling posters." Having been in the business for five years, Liptak knows that "poster sales enhance gallery sales and gallery sales enhance the poster sales, which both promote the artist. But posters really get your name out there."

Presentation. Submit color pictures of landscapes, florals, and animals—in other words, photographs of nature. Still lifes and soft-focus photos are also encouraged. The images should have a traditional look with recognizable images that are, as Liptak says, "very straight and apparent, which people can relate to," should be "easy on the eyes," should evoke a strong feeling, and should be consistent with your general style.

Payment. Bruce McGaw Graphics has a standard royalty contract and pays 10 percent of sales. This is a reliable source of income that is paid quarterly. The company does not offer photographers an advance, but it is willing to negotiate the length of time that the rights to an image remain in its possession.

IMPRESS GRAPHICS
Like most other poster publishers, Impress Graphics finds abstract photography to be a difficult area. Publishers are looking not to push unusual images on the public but to encourage the public to purchase their posters. Impress Graphics has determined that 90 percent of its retail customers are women who buy for the home. One of the company's photographic artists is Robert Farber. His pictures are soft, subtle, grainy. Impress Graphics has many of his nudes, but they do not sell in proportion to any of his other types of imagery because of their narrow market appeal. "There are very few women who go out and buy a nude to hang over the living room couch," explains Barbara Jordan, vice president of sales and marketing at Impress Graphics.

Impress Graphics also has two lines of quality publishing. The higher-priced gallery market usually dictates what will be sold at the mass-merchandising level six months to a year later.

Presentation. Submit slides or prints. Like most other poster publishers, Impress Graphics ac-cepts photography from all over the world. But, unlike most other poster publishers, the company believes in the artist sending "the more the better, at least a dozen." Jordan points out that "some [photographers] are very prolific. Sometimes we receive 100 slides or prints at a time." The editors at Impress Graphics prefer realistic studies or abstracts "with a painterly approach," adds Jordan.

Payment. Impress Graphics pays photographers an advance against royalties, then royalties. If the photographer prefers, the company will buy an image outright for a flat fee.

Moods. © Robert Farber.

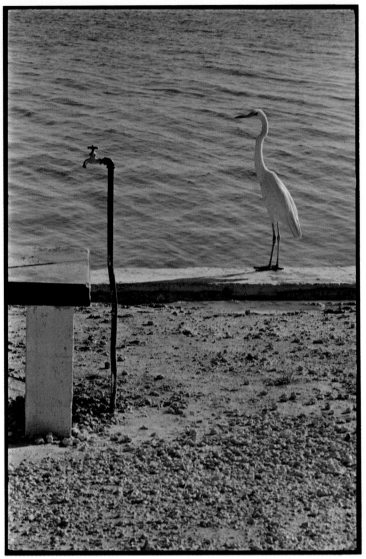

© Elliot Erwitt.

NOUVELLES IMAGES

One of the greatest poster publishers in France is Nouvelles Images, located in Paris. According to company president Jacques Blanc, interest in photographic posters is growing. Whether black and white or color, a poster must have a basic property if it is to be salable for Nouvelles Images—and most other publishers: viewers must feel that they can take something from the picture. In addition, viewers have to want to look at the poster while eating breakfast, explains Blanc. In other words, when people wake up, the photograph must give them the desire to begin the day, the desire to live.

When Blanc has seen a photograph that he liked in galleries or magazines, he has contacted the photographer about publishing the work. He has even come to the United States to meet with artists so that together they can choose the images for the posters. Blanc will at least write to an artist when a photograph catches his eye.

Presentation. Submit pages of slides or a series of prints. Nouvelles Images accepts work with universal appeal from photographers all over the world. Revealing a more unusual aspect of the company, Blanc says that he does not look only for photographs that will be best-sellers. He has published posters that he knew would not sell very well. Blanc explains: "I did it because I wanted to. And I am right. They do only sell a little, but this does not mean financial disaster. Because of the others, I can afford to do this from time to time."

Payment. Nouvelles Images pays a sum up front for the image, then another when the posters are actually published. Royalties follow.

CATCH PUBLISHING

Catch Publishing, which is based in Utrecht, Holland, takes great pride in its integrity. The first company to publish posters and cards of black-and-white fine-art photography, Catch wants to create "sellable publications of fine art for the public . . . which is difficult but must be done," explains Peter van den Brink, Catch's director.

According to the director, Catch does not publish just one image from a photographer's portfolio. More often it distributes between six and sixteen pictures, revealing an artist's work in-depth.

Presentation. Send duplicate slides or prints that represent all the images in your portfolio. If van den Brink is interested in seeing more of your work, you must be prepared to meet with him in New York, Paris, Arles, or London.

Payment. Catch Publishing pays an advance and royalties.

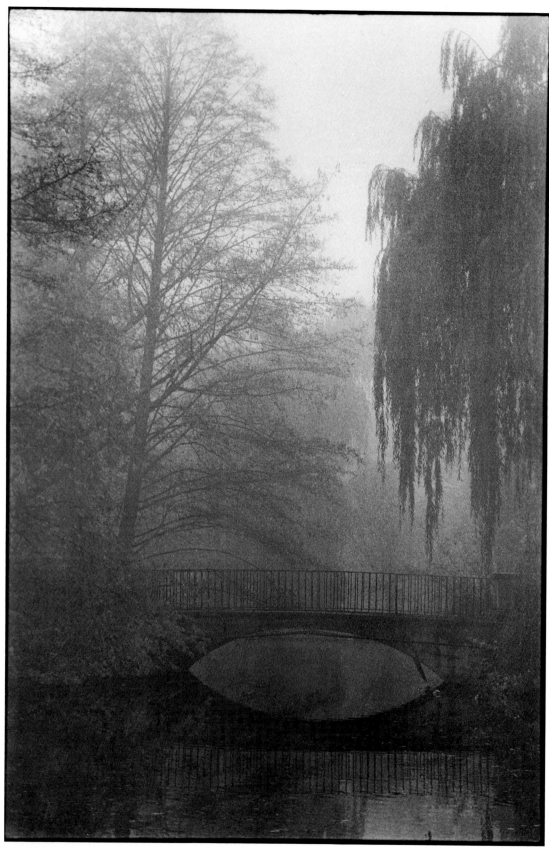

Lazienki Palace
Park, Warsaw, 1984.
© 1986 Eva
Rubinstein.

© Stephen Hender.

SELF-PUBLISHING

Self-published photographers can potentially enjoy control over the reproduction of their images, as well as the selection of images to market. These photographers also have better control of costs and profits.

CHROMALINE

In 1979 Stephen Hender started Chromaline in order to publish his color photographs. Having had successful shows in Seattle, Washington, Hender felt that his photography was viewed positively by others and would continue to sell. But when he started publishing his images, his problems with distributors also started. Because Hender wasn't widely known and his company was a vanity press, most distributors weren't interested. Furthermore, they told him that they didn't want color. Finally Hender found some freelance distributors who agreed to take his images on their rounds. Eventually poster shops, also called poster galleries, selling mass-produced and limited-edition posters began buying Hender's work. A year later, Hender was selling 600 posters a month, primarily on the East Coast. The photographer has found that "all of the big reps are in New York."

According to Hender, "the most difficult part in self-publishing is finding good reps." No matter how fine your product is, it won't sell if it's not distributed and made available to the public. As the poster market continues to expand dramatically, it becomes more difficult to find reps who will show your work. "The only way to motivate them is to sell. That means to constantly revitalize the line, put in new images, things that are going to make the reps money," Hender says.

The growth in the poster market has resulted in a flood of images in poster galleries. Hender describes one New York gallery: "Every inch of the wall is covered with framed posters stacked here and there and there against the wall." Nevertheless, these galleries fill the needs of people who want decorative "art" and have a budget of $60 to $100, such as upscale baby boomers who are decorating their first apartment or first home.

In addition to being decorative, a successful poster must tell a story and, according to Hender, elicit an emotion or reaction. People should be able to connect with the image, by

either being in awe of a beautiful photograph or simply being charmed by seeing something familiar in a new way. When he first started Chromaline, Hender decided to make a poster out of his best-selling card image Petit Dejeuner. He printed 3,000 posters but sold just 200. Hender recalls, "I thought it had every quality that would make a poster work. It told a story; it had good color. However, as it turned out, the colors were too dark for a poster. And you look at a poster for something deeper than you look for in a card." These differences are well worth remembering.

Hender offers some final advice about publishing your own work. He lays it on the line: "To be commercially successful, there has to be a certain base population which supports what you see."

FOOD FOR THOUGHT

Naomi Weissman started her poster company, Food for Thought, in 1984 "as a way of making money and getting [her] work 'out there' at the same time." She continues: "I find marketing posters more direct and in many ways easier than selling photographs. There's no pretense that the transaction is about anything loftier than making money." And, she says, "It is also quite gratifying to see how many people appreciate the work." In 1986 Weissman sold 5,000 copies of her Fruits and Nuts poster, and her Veggies poster is now in its third printing. "When you compare that kind of exposure with the typical exposure at a photography gallery," observes the photographer, "it's not hard to see the incentive to do posters."

When Weissman creates her posters, she puts words and images together, a process she has used with much success over the years. She finds that the posters do not threaten the market for her photographs. Her photographs are "the real thing," she explains, "and limited to an edition of fifty. They appeal to quite a different market."

GOLDBARR, INC.

Having been a painter and having shown her photography at museum and gallery exhibitions, Paula Barr realized that, for the most part, her images belonged in the fine-arts field. One of Barr's first posters was a poster commemorating the Brooklyn Bridge's centennial, which she did jointly with Sidney Rapaport as a promotional piece for his printing company. They split both the rights and the posters. When the poster became very popular, Barr created

Three Quinces.
© 1986 Naomi Weissman.

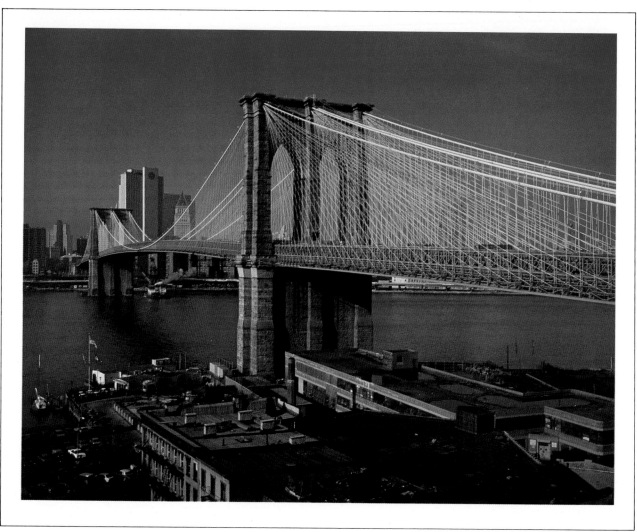

East River Bridge.
© 1986 Paula Barr.

Goldbarr, Inc. "It felt tacky. I didn't see myself as the next Peter Max," she recalls. But she knew printing; her first job was printing books for New York's Museum of Modern Art.

Barr finds that one of the biggest advantages to self-publishing is artistic control. In her view, another one of the riches of photography is unlimited editions. She sells 8 × 3 unlimited-edition posters for $3,000. "The technology is not about making images in limited numbers," she explains. While a poster enhances the value of the original for the collector, it also makes more art available to the general public. Barr continues, "As for markets accessible to me, some distributors will say, 'An image of New York City? I can sell anything about New York.' Others will say they don't want any more. It's not consistent. It depends upon the image."

Barr's goal is to publish one regular-format poster a year with national and international distribution. Her current print runs are 3,000 copies. Usually purchased in large quantities, the posters cost $20 each, of which Goldbarr's company receives $5.

DECORATION

November Sunrise. © Sonja Bullaty. From *Circle of Seasons*.

Decoration is a dirty word to most fine-art photographers. There are, however, fine-art photographers whose work is downright decorative, and the market for such photography is downright lucrative. Unfortunately, the biggest decorative photography deals often concern colors that match a bedspread or a set of office curtains. But if you happen to have a photograph with the right colors and theme, you have compromised nothing and have much to gain.

Basically, a decorative photograph must first and foremost please private or corporate clients, the buyers. Viewers might want a picture to change the

ambience of a bedroom or to improve the appearance of a conference room. It helps to know in advance how your photography will be used in order to organize your portfolio and create a presentation. Try to find out the color scheme, the desired effect, or the theme. And remember, "the client comes first." After all, clients pay the reproduction costs and then some.

John Santorelli, project director of Environetics International, Inc., a New York-based international design firm, finds that most of his clients don't consider photography to be an art form. As a result, they are not inclined to pay large amounts for decorative photography. This is a common phenomenon. "For the most part, many people, even art dealers, are not well enough educated to spend a lot of money on photographs," Santorelli explains. "They don't appreciate the work which goes into a photograph." Nevertheless, "more photography is now considered decorative, and more people are interested in putting photographs on their walls," says the director—and do pay for the privilege.

Photographers who sell their work for decoration find, naturally, that these clients get a great deal of satisfaction from displaying their fine-art photography collection. To help clients do this correctly and carefully, photographers should provide them with some information and advice. Before the package containing the art is sent to the client or buyer, by either you or your representative, include a note that explains what he or she needs to know. List the essential archival-quality ingredients of the framing, such as the acid-free mat and the board behind the print. If the client changes the color of the bedroom and wants to change the frame, the print remains protected. Next, specify the type of glass, such as den glass or Plexiglas, that should be used. In addition, stress that the photograph must be kept away from direct or strong light to prevent fading. There is much concern about longevity. But technological advances, especially in regard to color stability, have lessened this problem. Photographers can use such processes as dye-transfer and Cibachrome and Ektachrome Plus paper.

Photographer and self-publisher Paula Barr has sold her work to institutions, such as Bellevue Hospital in New York. Her large murals brighten the facilities. Barr's Cibachromes are laminated directly to Plexiglas, which are archivally sympathetic, as she explains, because both are plastic. For the buyer who wants a framed print, Barr's work is ideal; assembling the art is an intrinsic part of her talent. Barr has found a large-format mounting technique that is good for, at the very least, the client's lifetime.

Sonja Bullaty and Angelo Lomeo, well-known photographers of great paintings and the creators of photographic masterpieces, believe that a fine-art photographer has a tradition to live up to. "Because we have looked at great art, you are that much more demanding on yourself," explains Lomeo. While he and Bullaty supported themselves for many years by working for museums and galleries, their photography projects led to numerous books, cards, and exhibitions.

Despite their success, Bullaty and Lomeo are concerned about today's photography market. With all of the bad color photography bombarding the public, the fine-art photography market has been hurt. "It's bad press," Bullaty says. "This is what we're up against as fine-art photographers. We must still convince the public and collectors that photography is a legitimate art form."

Decoration is one of the most subjective words in the world of the home and office. The chances are good, then, that your work will suit a potential client's preferences or needs. You don't have to alter your portfolio to make it do so. What you do in an attempt to satisfy one person's taste may only thwart your efforts. For the sake of your work and for peace of mind, let the buyers find your work fitting and let them pay for it.

CLIENTS VERSUS COLLECTORS

Unlike collectors, clients prefer images that evoke a feeling or help them want to live. Many look for a piece of the world through which they can temporarily forget their own or make their lives more tolerable. Buyers will pay the photographer's prices; however, they may request a package deal at a price that includes appropriate prints in various sizes.

There are several differences between selling a photograph to a collector and selling a photograph to a client for decoration. Many buyers often make a selection and assume it will be ready for installation in just a few days. Most corporate buyers have their own framer. But many private buyers assume that the photographer is a framer or is responsible for having a frame made. Because of the time required to get and assemble the materials for the frame or to make repeated trips to a professional framer, the photographer loses valuable shooting time. Collectors, on the other hand, are only concerned with the photograph. Most collectors focus on the photographer's credentials and the photograph's number in a limited edition.

The sale of a photograph used as decorative art can be one of the most honest exchanges between a buyer and a photographer. The photograph will be enjoyed, contemplated, and appreciated.

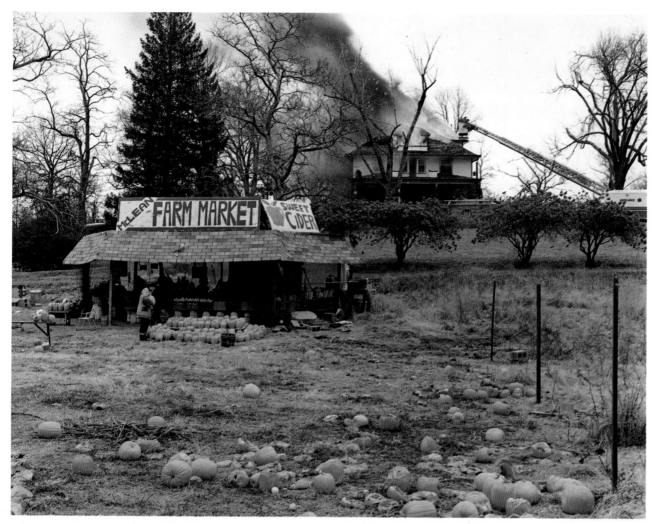

© Joel Sternfeld. Courtesy of Paul, Weiss, Rifkind, Wharton & Garrison.

WHAT CLIENTS WANT

Most buyers of decorative photography are interested in adding another look at life to their environments. As a result, your picture will be viewed, not stored. The image may show a familiar object in a client's life in an unusual way. The image may be a photograph of another world entirely, which makes the client less restless in his or her own. In any case, what constitutes "decorative" photography is determined by the individual client.

COLOR OR BLACK AND WHITE?
As Jean-Claude Lemagny, photography curator of France's Bibliothèque Nationale, points out, color photography is becoming more and more available. But the popularity that decorative color photography has enjoyed during its short history has declined because of the vast number of bad color photographs, for example, in magazines and on billboards. Good color photographers are, however, fighting back.

Black-and-white photography will always sell. The look is classic and reflects proven,

quiet taste. Paul, Weiss, Rifkind, Wharton & Garrison, one of the largest law firms in New York, fills many of the office's public spaces with black-and-white photographs. Neale M. Albert, curator of the law firm's collection, says he has 400 images of fifty-three photographers. Of these photographs, about 300 are black and white, and 100 are color. And, he is always looking for more.

Ironically, most people regard black-and-white photography as the medium that best reveals the real world. After all, the real world was first represented in black-and-white photographs. In addition, color is so often exaggerated or distorted that the world of black and white is believed to more accurately reflect the world in which we live.

CORPORATE CLIENTS' SPECIAL NEEDS
Office Design Associates, a New York firm, has found that its clients prefer "a major bang of artwork. That can mean a recognizable image or abstract." According to Ed Bajbek, the company's director of design, many clients now want modern rather than traditional images.

"The president of the law firm is now forty-five, no longer seventy-five. He is contemporary by nature and wants contemporary things around him," Bajbek explains. He sometimes buys photographs in series, "to get the maximum out of the minimum." He then works with the same subject, altering its direction or flopping the same picture repeatedly. "By flopping the image," he points out, "you can create your own series. You get a large dramatic piece of artwork as opposed to one piece on canvas."

Rather than work with reps, who are shut out by many designers, Bajbek advises photographers to present priced packages. Offer clients collections that range in price, and describe the variety and number of sizes and combinations of the prints.

The clients of Office Design Associates are like most clients throughout the world: they have to be pleased and are always looking to get the most for their money. Decorating budgets have gotten smaller and office space tighter for most companies. As Bajbek says about most clients:

If he can get four 30 × 40s for less than one painting, he is happy. As of 1986–1987, executive offices were most frequently allotted $400 to $600 per piece of artwork per space. It doesn't matter about the photographer's credentials. If the photograph works in the space, it's purchased.

Photographer Judith Borst Smith is frequently hired by corporations to shoot their products in her style. When Johnson Industries hired Smith, she concentrated on welding sparks and washing machine parts, creating fantastic designs. The photographer changed fighter-plane wing-tip lights into heart images. She ultimately transformed the Navy's Hawk missile parts into a stained glass window.

Smith, who works alone, offers clients a cor-

porate package. As of 1987, she charged $500 per day for shooting, $60 per hour for designing, and $20 per hour for cutting and piecing. The cost of film and processing are extra, as is the charge for the final print in large format.

Smith's photographs are used for magazine covers, company brochures, and boardroom walls. "I believe that by narrowing my field to what I do best, I create a total environment for achieving my best creative efforts," she says. Smith also alters her clients' environments.

The Prudential Life Insurance Company looks to decorative photography to improve the appearance of its offices. According to Helene Zucker Seeman, manager of the art program, the company buys approximately fifty photographs a year, often in series, primarily of emerging artists. "They are accessible, affordable," she explains. All of the work is catalogued and inventoried.

Prudential prefers not to purchase prints smaller than 16 × 20. "Sometimes we go to a photographer and ask if he or she will make a larger print," says Seeman. When Prudential purchased Jerry Uelsmann's photography, Seeman wanted a larger format of the image than Uelsmann had shown. It took the photog-

rapher several months to decide whether or not to make the larger format print. Because Uelsmann does all of his own multiple printing, he managed to produce the large-format print while working as a graduate research professor at the University of Florida. It now rests on permanent display at Prudential.

Hotel chains comprise a large section of the decorative photography market. Unfortunately, however, their big budgets are severely hampered by the need for mass appeal and the high incidence of theft. As a result, hotel use of fine-art photography has been adversely affected. Still, any private or public display of your work promises visibility, if not financial rewards.

Underwater photographer Susan Swygert works in the photography center at the Flamingo Beach hotel on the resort island of Bonaire in the Netherland Antilles. While Swygert's photographs are used for decoration by the Flamingo Beach hotel, the hotel does not pay for the prints or their reproduction. Nevertheless, the photographer is satisfied with the arrangement. It offers Swygert both artistic freedom and control. "I'm always using my creativity since I'm sending out photographs of my choice," she explains.

Ireland Estuary.
© 1984 Kathryn
Marx.

PRIVATE CLIENTS

Janice Gewirtz, president of Innerspace, winner of RCA's first prize for her video designs, featured designer in the *New York Times* Home section and *Metropolitan Home*, designs spaces for private use primarily. She finds that "only the most sophisticated clients are interested in buying photography." For most private clients, Gewirtz adds, "the colors must match the decor." In her view, "photography is only for those who come with a serious interest in art, rather than somebody who is looking for something to make their couch look good."

One of Gewirtz's clients, Frederic Vandenberg, wanted a 30 × 40 photograph for his living room and a series of 16 × 20 images for his bedroom. As Gewirtz explains, the client said that "the image for the living room had to match the colors of the room, red and grey, while the images for the bedroom had to be grey. And they did." She continues, "I let the client choose the images he wanted from my portfolio. The only changes that had to be made were changes in size."

Underwater photographer Susan Swygert has both corporate and private clients. In fact her exposure through corporate clients, such as the Caribbean Hotels chain based in Miami, Florida, helps her private business. Clients are drawn to the breathtaking blues and corals in her images, as well as the spectacular views. Swygert is living every photographer's dream: she is working where she wants to and is doing what she wants to do.

EVENTS

Untitled #3, 1980. © 1980 Joyce Neimanas. Courtesy of Center for Creative Photography.

Most photography events feature well-known photographers in order to attract an audience and investors. Sponsors are anxious to profit from their support of this fine art. But there is room for new talent, and viewers will take notice. Attending a national or international photography event will bring artists face-to-face with several important facts, including the huge number of people who call themselves photographers, as well as their desire for recognition, their need for financial support, and the necessity of travel.

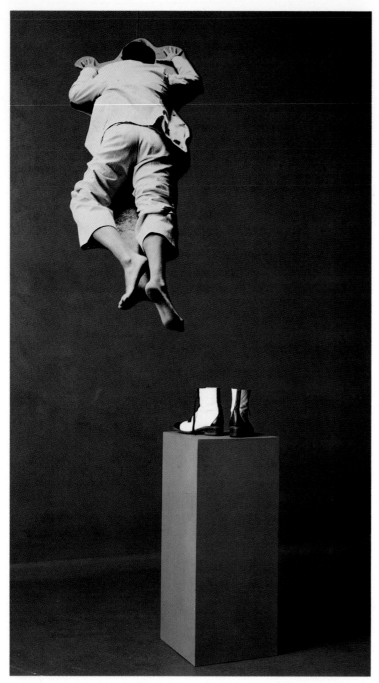

Jump. © 1981
Marinus Boezem.
Courtesy of
Lawndale Art &
Performance Center.

THE NATIONAL SCENE

Critics and photographers used to say that if you didn't show in New York, you didn't really show at all. Because of the strength and diversity of the photographic art market in New York, it is easier to proclaim yourself a photographer there than it is anywhere else. However, it is also harder to prove.

The increasing interest in and focus on photography in other parts of the United States, however, warrant close attention. As curator of the Museum of Modern Art in San Francisco, California, Van Deren Coke has greatly influenced the appreciation and support of photography as fine art. The Center of Creative Photography in Tucson, Arizona, is a major force in contemporary photography. Each year a number of exhibitions are held in the center's Contemporary Gallery. These shows feature new work with a full range of color and black and white.

THE HOUSTON FOTO FEST
In 1986 the Houston Foto Fest, the first major international exhibition ever sponsored in the United States, was held. The festival was founded by gallery owner Petra Benteler and Professor Frederick C. Baldwin as America's answer to France's Mois de la Photo. The Houston Foto Fest began with a mailing of 250,000 brochures to photographers announcing the portfolio review. "We got our list by buying lists from 'Friends of Photography' and 'The Photography Collector,'" explains Benteler. "If at the next festival there are 500,000 photographers lining up to show their portfolios, that would be wonderful."

During the three-day festival, 100 notable photography dealers, curators, and editors did nothing but review portfolios. Some photographers were also selling privately; many were represented by their dealers. Bernard Faucon, for example, was represented by the Houston Center of Photography while he continued working in Paris. At least 1,000 completely unknown photographers with a lot of good work attended.

The next Houston Foto Festival is scheduled for 1990. Photographers are encouraged to submit at least twenty-five photographs or slides that represent their body of work; however, the review board prefers images curated at the Foto Fest by a museum or gallery. The criteria for selection include the quality of the work, funding, and the amount of space available.

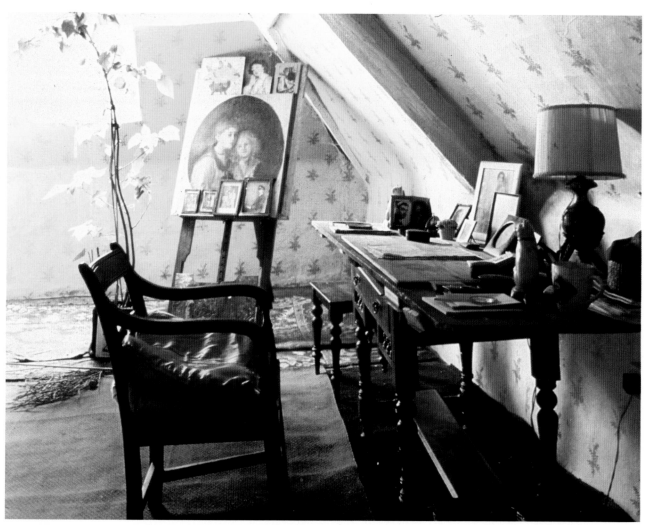

Louba's Desk.
© 1981 Andrew
Bush. Courtesy of
Lieberman & Saul,
New York.

THE INTERNATIONAL SCENE

Fine-art photography thrives in France in part because of the exposure it receives through the Mois de la Photo and the Arles Photography Festival. Much of the financial support for the photography comes from the Musée d'Art Moderne in Paris, the Georges Pompidou Museum, the Ministry of Culture, and a few risk-takers, such as Michele Chomette, Agathe Gaillard, and Vivian Esders. Chomette, for example, met and encouraged Touhami Ennadre in 1975 when he arrived in her gallery with very small photographs, the only size he could afford. By 1984, according to *Camera* magazine, "the giant-size photographs of his portfolio caused quite a stir in Arles." And in 1986, Chomette featured Ennadre during the Mois de la Photo. Scheduled for 1989, Germany's Art de Cologne is planned as a biennial event, featuring all types of fine art, including photography. At Photokina, which began in 1953, photography is given space, but the emphasis is on marketing photographic technology, equipment, and gadgets. The event includes many exhibitions, attracts approximately 126,000 people each year, and receives a lot of press—and photographers receive a lot of exposure.

The Ministry of Culture funds the Mois de la Photo, the Arles Photography Festival, and the National School of Photography in Arles, as well as regional exhibitions. Agnes Gouvion St. Cyr created the Ministry's photography department in 1975, thus establishing photography as a cultural art. The Ministry and the National Center of Photography jointly hold numerous exhibitions of contemporary photography each year at the Palais Tokyo. Together, they also publish the Photo Poche paperback series, which includes the work of such photographers as William Klein, Joseph Koudelka, Bruce Davidson, and Joel-Peter Witkin.

THE MOIS DE LA PHOTO

Now a major photography festival, the biennial Mois de la Photo was first held during the fall of 1980. At the time photography's place in museums and galleries was all the more uncertain. But founder Jean-Luc Monterosso took the risks. Vintage and contemporary images filled the streets and subways of Paris, awakening and educating the public. Photographers from all over the world came to the Mois de la Photo to show their work, to view exhibitions, to learn, and to make contacts.

The 1986 Mois de la Photo included seventy museum exhibitions, gallery exhibitions, and privately organized debates and shows. An international jury, whose members came from Czechoslovakia, France, Switzerland, and the United States, awarded three prizes of 100,000

Autres Ameriques.
© Sebastiao
Salgado.

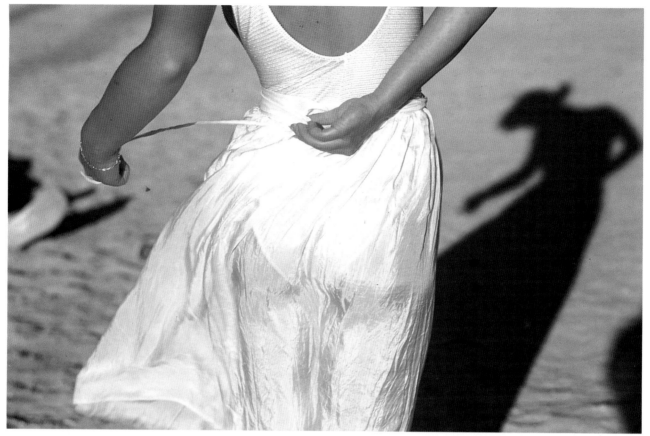

© Marie-Annick Bertrand.

francs each. The public voted on their favorite photographers. The Mois de la Photo inspired similar exhibitions in Amsterdam, Spain, Italy, and the United States. This festival, held in the land of Fresson, the land where photography began, reaffirms photography's place in the world of fine art.

ARLES PHOTOGRAPHY FESTIVAL

The seventeenth annual Arles Photography Festival will be held in July, 1988. Arles is crowded with eager photographers from all over the world. While much of the portfolio review takes place at the Hotel Arlatan, photographers with open cases can be seen in cafés and bars throughout Arles. Lucien Clergue, renowned photographer and founder of the Arles event, adds:

> The goal of the Arles Photography Festival is to bring people together who are interested in photography. Galleries are invited to show their stables as well as individual photographers who wish to come and show their work. There are at least 2,000 people present for the evening when we show films, slides, and video in the amphitheater. You can find a gallery or a publisher. Some photographers make their year here.

Sygma photojournalist Christine Spengler, best known for her war photographs, presented The Mourning of Eric, her series of highly personal color slides, at Arles. The series surprised many who knew only her startling black-and-white documentary work. Another part of Spengler's photographic vision was revealed here, leading to more exposure and more interested viewers.

Gallery directors from all over the world come to the Arles Photography Festival to receive any photographer who wishes to show his or her work. Photographers may have to wait on line for their turn to be seen, but they may well find a publisher or be offered an exhibition in California, New Orleans, Geneva, Milan, Paris, or Cologne. Different countries have different likes and dislikes. French photographer Marie-Annick Bertrand was approached by a German postcard publisher interested in her Wind of Silk image.

Franco Fontana, one of Italy's greatest photographers, speaks for many of his colleagues: "For me, Arles is a must."

Photography is still considered by some to be an alien to the art world. Although interest in photography and its acceptance as an art form are increasing, photographers still struggle to gain recognition. Many inexperienced photographers look at Ansel Adams' success and think, "That's for me." This is utter naiveté. A successful career as a photographer begins slowly and builds only with persistence and talent.

Alberto Giacometti,
1932. © Man Ray.
Courtesy of the
collection of Lucien
Treillard, Paris.

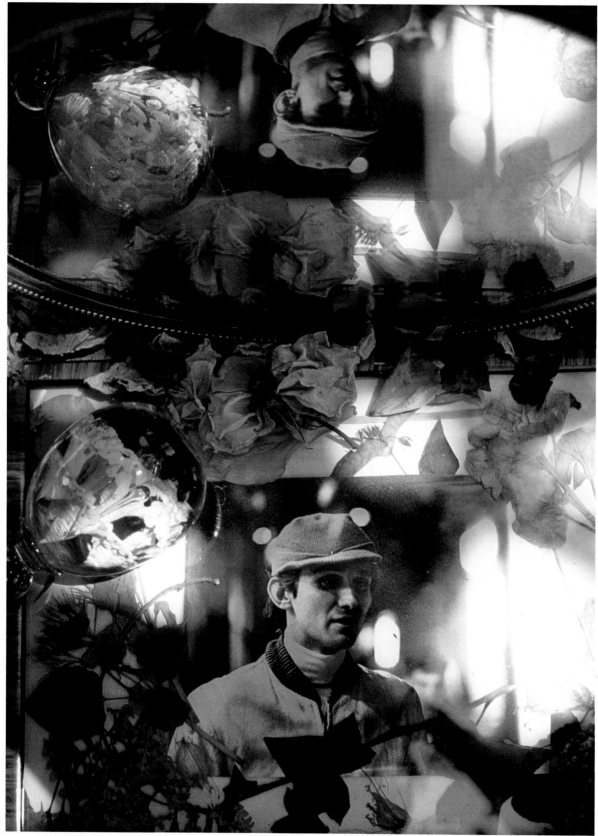

Eric. © 1983
Christine Spengler.
Courtesy of
SYGMA.

ALTERNATIVES

Dogon Mother, West Africa. © 1987 Elisabeth Sunday.

There is a way to ensure a market for your work—a market that is guaranteed to be noncompetitive. Create your own. When you come up with or discover a use for your photography and a way to promote and sell it, you have something no one else does. Such is the nature of auxiliary markets for fine-art photography.

Sandy Skoglund, a New York-based artist, has carved out her own niche in the fine-art world. She enjoyed immense success during the 1986 Mois de la Photo in Paris. Skoglund's work, which includes her sculpture and painting, is conceived and designed with the photographic image in mind.

Skoglund has not been pigeonholed as a sculptor, painter, or photographer. She is regarded as a talented artist. Isn't that the goal?

Finding an unusual market for your fine-art photography may not only be the most important discovery of your career; it may also lead to one of your brightest moments. When photographer Bruce Weber started working with fashion designer Calvin Klein, he carved out a niche for himself. Weber brought his own style to the work, which has appeared on billboards, in magazines, and much earlier in the Texbraun Gallery in Paris. The photographer's style has been copied and admired as well as hated. Some think that Weber's style has merely stagnated. Whether you think of Weber's work as fine-art photography or fine financed photography, whether you admire or hate his work, Weber has undeniably achieved distinction in and made a unique contribution to the overcrowded world of fashion photography.

Creating a new or unique market can be done. The market may or may not be appreciated, funded, or profitable. If establishing the market requires more time than available funds allow, but your passion for or belief in your project is still strong, more traditional markets can be used to finance any alternative concept.

CREATING A MARKET

Why create your own market? Photographer Elisabeth Sunday states the case quite clearly: "I just couldn't see how getting a high-paying, subprofessional job like waitressing was going to feed me, my landlady, and my darkroom." Sunday created a market for her photographs. She did have some doubts initially, though:

> I thought that once someone got used to the security of working for someone else, it would be hard to wing it in the world and go back to taking great risks. I thought it would kill my high spirits and enthusiasm.

Out of sheer necessity, Sunday began the Artist's Support Group Network. The photographer invited ten of her best clients to join a "print-of-the-month" program and offered "significant discounts" if they subscribed for a minimum of six months. Sunday explains:

> It was called a "network" because their friends could also come in and buy at the low prices on their membership cards and count as a monthly purchase for the member, thereby expanding the network and my mailing list. They also had to send checks regularly and on time regardless of whether or not they picked up prints so I could cover my expenses. I kept my studio open Sundays from two to five or by appointment for my network.

The photographer offers some advice and encouragement. She says, "We have to know how to approach the market, how to appeal to it. Some basic business sense is a must these days. It can be done. I did it."

Dominique Gaessler, a Paris-based photographer, uses an exceptionally large format. His studies of urban areas are completed with city funds because the cost of enlargements for an exhibition is financially prohibitive. He adds: "That my images are in the streets, seen, so they pose questions to the public concerning their lives, to take photography beyond its small world, this is fulfilling, this is important to me."

Photographer and self-publisher Paula Barr has harnessed the power of photography to improve institutional environments. Her goal: "To install photomurals in public places associated with stress." Barr works on a project-by-project basis and completes a project in approximately eighteen months. Her initiative has proven to be highly effective and successful.

Barr's images have been purchased by the Long Island (New York) Railroad for display in its stations; Goldwater Hospital; and New York's Bellevue Hospital, where two 8 × 20-foot murals have been installed. Bellevue's art and design staff then contacted the photographer, wanting her to install a mural in the new area designed and built solely for the use of prisoners from Riker's Island. Physically and mentally ill inmates would be able to visit with relatives and clergy in this room. Barr consulted with the hospital's suicide prevention staff and correctional staff before deciding on the image that would change the environment most effectively.

A more appealing project was initiated by the Metropolitan Transit Authority's Art for Transit Office and was arranged with the cooperation of Barr and the Long Island Railroad. One of Barr's murals was installed in Pennsylvania Station behind the ticket office. The 2-foot high, 52-foot long mural was the first to be hung in the busy railroad station. The exhibit received funding from Con Ed, Helmsley-Spear, Inc., Mid-City Associates, Chroma Copy International, Erizan, Inc., and Fuji Film USA, Inc. Barr represents herself and finds this the most efficient way to retain artistic control and to put a deal together satisfactorily.

Inspired by the bullfights in Spain, photographer Christine Spengler set up an impromptu "studio" for three months at the entrance of arenas in Madrid, Sevilla, Barcelona, and other cities. Because toreadors are superstitious about wearing their "costumes of light" outside the arena, Spengler took their photographs against the brick wall of the arenas. In her inimitable style, she decorated the walls with objects belonging to the toreador and reshot the images.

Montbéliard. © 1987
Dominique
Gaessler.

© Kathryn Marx.

The toreadors loved the portraits, which Spengler had done without pay. They soon started using them for publicity, making postcards and posters. It wasn't long before the bullfighters' tailors and shoemakers, such as the famous Spanish firm, Elda, paid Spengler for photographs to use for publicity purposes. Spanish bullfights traditionally have been publicized through paintings, and Spengler has become the first photographer of bullfight posters. Her series of portraits of toreadors comprised a major exhibition at the 1987 Arles Photography Festival.

Placing your photography in a shop window display may not make you a camera bag full of money. However, the visibility outside of the world of photography offers the potential for other sources of income. Even world-famous Tiffany and Company, located on New York's Fifth Avenue, does not pay photographers well. As window designer Gene Moore says with his customary frankness, "You're an artist. What do you expect? Of course you're going to be paid a ridiculous amount." This means $250 from the company, an amount that barely covers the cost of images for one of the five windows. However, one sale can cover all your expenses. Because so much depends on the location of the display and the company showing your photography, Tiffany's is hard to resist.

When I decided to approach Tiffany's display department about making a presentation, I wrote to Moore, enclosing some samples of my work, and then telephoned. I was given an appointment to show my portfolio—on a date several months away. This surprised me. But I learned that Moore schedules displays at least one year in advance. After seeing him several times over the course of a year, he arranged for my photographs to be in Tiffany's windows a year later.

Moore, who has designed theatrical sets and costumes, jewelry, and Tiffany's windows since 1955, explains his criteria for selecting an artist's work:

> The choice is a feeling exactly the same as knowing which painter I like better than another. Choosing a photograph is something I relate to visually and emotionally at the moment. I believe it can happen that you immediately have an association when something is good.

In general, Moore prefers color photographs, be they realistic or abstract, or horizontal or vertical. He also says that the images cannot be glossy or too dark because of the inevitable

reflections from the spotlights, and window glass creates sidewalk mirrors.

Moore's sensitivity to all the elements in a photograph and the jewels is remarkable; the obstacles of space, window reflections, and lighting do not prevent him from designing spectacular windows. And, adds Moore, "I've had people call and ask how they can get in touch with the window's photographer. It's one hell of a showcase." I have to agree: I sold four of the five images I had on display at Tiffany's.

INNOVATIVE STRATEGIES

Regardless of the market you wish to enter or create, your entrée requires talent, visibility, and good judgment on your part. Photographer Harvey Edwards explains:

> In the years to come, photographers will be translating their work in a huge market. But they need to be involved in the design aspect to do this with photography that says something. They can't just leave the image and say good-bye. They have to be sure to get a result to their liking.

Edwards' close examinations of dance have brought him contracts from publishers of magazines, cards, and posters. Based on these successful deals, he has arranged for his dance images to appear on mugs, tins, and sleepwear. Edwards feels that his wide-reaching market is opening up to photographers and will continue to do so in the future. But, Edwards warns, you should choose the products on which your images will appear with care, and negotiate for as

much artistic control as possible.

Unlike Edwards, well-known photographer Franco Fontana has found over the years that neither books, postcards, nor posters enable you to make the kind of money that can come from finding your own niche. By developing a special, recognizable style, you cannot help but be asked to create your kind of work for a variety of clients. This is another way to get carte blanche in order to produce the kind of photography you want to create, as Fontana does.

Fontana's renowned landscape images have been used by such clients as AGFA, for a calendar with international distribution; Fiat, Kodak, and Fuji, for advertisements; and Italian banks, for books on various regions of Italy for their customers. The photographer is paid handsome commercial prices for producing the landscape images these companies want and need. As Fontana says, "They are a source for living in the material world."

Some of Fontana's other clients include Volkswagen, Ferrari, Volvo, and *Vogue* magazine. These deals resulted from Fontana's visibility in such magazines as *American Photographer* and *PHOTO Magazine*. His photographs are used for the clients' brochures, advertisements, annual reports, and other publications. Fontana explains why he enjoys his own special type of photography so much: "It's very different from studio art. To have the work dictated is not for me. Photography for me is the way of freedom."

Another photographer who has enjoyed the versatility of the photographic field is Sylvia deSwaan. Having been an exhibiting photogra-

© Franco Fontana.

© Sylvia deSwaan.

© Stephen Hender.

pher for twelve years, she is now the director of Sculpture Space, a nonprofit work space located in Utica, New York, that sculptors can use on a limited basis. Recently, deSwaan landed a plum assignment in a different market: shooting the production stills for Academy Award winner Peter Watkins' latest film. The stills will not only publicize the film, they will publicize and finance her other work. Although the photographer did not earn a fortune, she did have the opportunity to work with one of the most innovative filmmakers of our time.

Independent filmmakers usually shoot in odd places. When a film is shot outside Hollywood, find out who the director and producer are and ask for half a day on the set. Make your services available. You have to be inventive if you want to do this kind of work.

Mark Feldstein, whose reputation was built upon his unusual photographs of New York, was approached by the set designer of the Broadway play, *The Tap Dance Kid*. Feldstein, in turn, approached Kodak. A mammoth Durantrans was created for the production; Kodak wanted the publicity and paid for the materials. If you can't put your best photograph forward, why not make it appealing to Kodak, Fuji, or Agfa and convince them that it is worth the investment?

Photographer Stephen Hender found old-fashioned street fairs to be instrumental in deciding the direction of his career. One of the long-standing auxiliary markets, street fairs expose your work to many potential customers and provide you with many different reactions to your photography. When Hender tested his market at a street fair, he discovered that he could make between $4,000 and $5,000 during one weekend festival. This success made his plan to begin his own card company seem all the more reasonable. The company Chromaline has proven to be quite lucrative. The cost of displaying your work at a street fair can be well worth the investment.

Architectural photography is another auxiliary market that offers many opportunities to fine-art photographers. Judith Turner photographed the renovation of Cooper Union in New York with a strong sense of style that even surprised architect John Hejduk who had hired her. Turner's large exhibitions in Tel Aviv and Tokyo, however, revealed just how unusual and unique architectural photography can be. If you agree with the other photographers who consider working with architects to be too structured, take a look at *Judith Turner Photographs Five Architects*.

Another artist who has explored the architectural photography market is Jean-Marc Tingaud, whose images have appeared in *Vanity Fair*, *Vogue Decoration*, and Club Med adver-

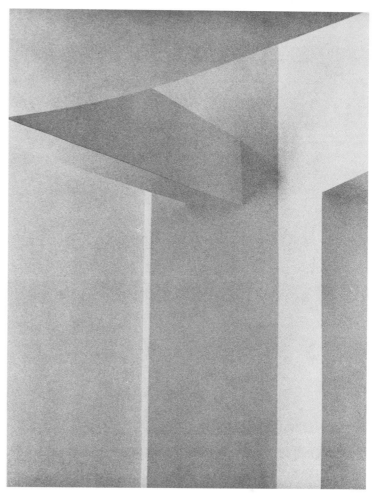

Cooper Union Renovation, 1978, New York City. © 1978 Judith Turner.

Port-au-Prince,
2/86, Family Calls
Shack Home, Haiti.
© 1986 Eli Reed.
Courtesy of
Magnum Photos,
Inc.

tisements as well as museums. The photographer found a project that would allow him to express his personal style and his creativity. The project concerned the rehabilitation of a section of Macon, France. Tingaud decided on an intimate photographic exploration of interiors. The result: images of twenty-four people with "the most important objects in their lives—their objects of love."

One of the most widely investigated and long-standing markets for photographers is photojournalism, often considered a career unto itself. Because photojournalism always requires a photographer to work within a certain time frame and dictates the subject, the results are sometimes predictable. But some photographs from Magnum's collection are indisputably fine art. These are exceptional images that evoke emotion and draw the viewer to the photographer's perspective, such as those taken by Eugene Smith, Lewis Hine, Susan Meiselas, and Charles Harbutt. Magnum's list of photographers has also included Robert Doisneau, Henri Cartier-Bresson, and Robert Capa.

Robert Dannin, editorial director at Magnum, explains one of the reasons for the company's success: "When every journalist in the world is on his way to cover an event or is on his way to a country to do a story, the Magnum reporter is on his way back." Other elements important to Magnum's success are the emphasis on personal points of view and the respect for individuality. Often when several Magnum photographers cover the same place or event, several different looks at the same thing are the result. Dannin explains: "What can come back from one coverage is an entire spectrum of photography. The photographers have done art photography, avant-garde journalism, or straight news work. All for Magnum."

A photographer's collective, Magnum is owned by its members. "Everything is self-financed," says Dannin, "or we get some financing from somewhere, which is my job to find." When magazines pay Magnum for the use of photographs, Magnum divides the fee according to its seniority system. The photographers pay the organization to cover both the operating costs and the potential costs of expansion. Because Magnum is made up only of photographers, their integrity is intertwined and is not compromised.

In order to join Magnum, photographers must submit a portfolio, which will be reviewed at the annual members' meeting. "We ask photographers not to submit anything that is designed to appeal to either Magnum photographers or an audience, but what they consider to be their personal work," adds Dannin. Once the period of nominations is over, a nominee becomes an associate member. Full membership does not depend on being published but on submitting a unique body of work.

The Image Bank is primarily a stock photo agency with a network in thirty-five countries that represents 350 photographers. But the agency "prefers photographers who keep with their own personal style," points out vice president Lenore Herson. "The more individual style, the better."

For commercial photography, which makes up all of the Image Bank's list, the pictures are channeled to and from the agency's offices throughout the world. Some of the photographers who produce such "commercial" photographs are Jay Maisel, Joel Meyerowitz, Sonja Bullaty, Angelo Lomeo, Pete Turner, Shinzo Maeda, Yoshikaza Shirakawa, and Franco Fontana. Photographs selected from the Image Bank have an endless number of possible uses. Magazines are the first that come to most photographers' minds because they offer such great exposure to potential clients, but some of the other uses for images have included sales for private collectors, calendars, advertisements, fabrics, t-shirts, and tin boxes. "A good photograph should be commercial in the sense that it should be used and thus seen," says Herson.

In order to be considered for representation by the Image Bank, send a letter requesting procedures for submitting your portfolio. "We can't buy from photographers who have only 200 images to show. They would only get lost here. We need photographers who are shooting all the time," explains Herson. While the franchises take 40 percent off the top, the New York office splits the payment equally with the photographer.

A large agency can work for or against you. Unless you have a huge body of work that is continuously growing in quality and quantity, you can get lost in the shuffle. Having a large quantity of quality images at your immediate disposal is essential in this case.

Port-au-Prince, Near Cemetery, Haiti. © 1986 Alex Webb. Courtesy of Magnum Photos, Inc.

© Patrick Boucher.

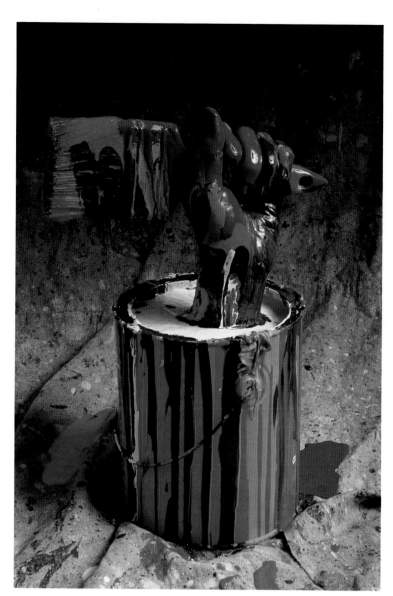

There are always photographers who find their individually tailored markets quite effectively. Patrick Boucher has been making Cibachromes in the Paris shop, Dubois, for the last five years. One client sought out Boucher's sharp eye and good advice; he was looking for a particular kind of photograph for a book jacket. Boucher, who keeps his portfolio case close at hand, has been paid for his photographic book jacket ever since.

A photographer's market outside photography's mainstream possibilities, such as the summer photography workshop circuit, reflects the personality of the photographer's "fine art." Because so many people have cameras, photographers too often find that they are asked to work for nothing or for a stock house that insists on holding the copyright to their pictures. This need not happen—unless you share the opinion that your talent and time don't deserve to be paid. Hold fast to your viewfinder, and let it be your guide. Then the market for the fine-art photographer is, in fact, customized to the unique quality of your work. The potential of the market can be yours and yours alone with all of your individual potential.

No Metal Boxes.
© Gary Gay.
Courtesy of The
Image Bank.

APPENDIX

Untitled. © 1987 Victor Schrager.

Staying alive in any profession means taking care of your own business. Some people have no trouble marketing, selling, pricing, and supporting their work while others find this to be overwhelming. Some photographers prefer to work without any agent of any kind at any time. For those photographers whose vision rests strictly within the viewfinder, a representative can be indispensable. Representatives take care of other people's business better than they themselves could. Representatives can negotiate profitable deals for artists and prevent them from being exploited.

The best advice anyone can offer a photographer is a sharply focused perspective about the photographer's strengths, potential value, and integrity. Your particular talent may not lend itself to the business side of photography. If this is the case, find a business representative. If you hold firmly to what is yours, you will find that fine-art photography can be a rewarding venture. Consider the following business matters before you enter the fine-art photography market.

EXTERNAL REPRESENTATION

A representative can be a wise investment. Representatives are practical people who have a sense of the market, an eye on the latest trends, and occasional dinner invitations from buyers. They possess the ease to discuss money matters, as well as what will and will not sell. Some reps tell a photographer quite frankly that they dwell on the other side of the fine-art market—the business side. Of course, the relationship between a photographer and a rep first and foremost involves mutual trust.

When you first meet some representatives, they flip through your portfolio very quickly, looking for a specific type of image for a specific buyer for a specific deal. This is the business world. There is no time for reprints or reshoots. The desired image must be in your portfolio. The reps' job is to know the markets' preferences and needs, not to tax their imagination thinking about how you could do exactly the shot they're looking for in just a few days. Photographers can then continue to work on their uncompromised fine art.

Having a representative can save photographers valuable time another way. An artist's rep often works with a framer on a regular basis and may offer installation service to the client as part of the fee. This enables the photographer to concentrate on photography. It can take quite a while to find a group of people who like your work, believe your photography is as good as you do, and are willing to invest in it.

COMMERCIAL PROJECTS
Peter Riva, photographer Franco Fontana's agent, states the role of the representative in no uncertain terms: "The agent's job is not to get in the way." He continues: "The agent's job is to find somebody who would like something from the photograph and tell him how to put it to the photographer. Then I let the two of them have a direct conversation." If this is impossible—as it often is with Fontana, who lives in Italy and speaks little English—Riva steps in. The agent explains:

Franco's work is of such a high quality that all you have to do is make sure that there is some-body there who knows how to negotiate for him when the people phone. That allows him to concentrate solely on being creative. And that guarantees that his work will always be fresh, new, and lively.

When Riva began working with Fontana, the agent's first decision was to "get him out of the photography galleries where they sell photographs like postage stamps, collectibles." At such places, Riva maintains, "The photographs are sold based on what's on the back, the number, the signature, the condition. It's a control system to validate the art." The agent then took Fontana to the advertising agency representing General Motors, an American car manufacturer. He put several slides that he liked into the projector and received a round of applause. "Franco hadn't gone out and solicited an advertising agency in his life," adds Riva. Similarly, when Fontana received a trial assignment from *Vogue*, he selected and submitted the photographs he liked. "Nobody's ever done that," explains Riva. "He doesn't worry whether they are pleased or not. He only wants to do good things. *Vogue* went completely crazy for his work."

In addition, Riva "keeps a little stream of mail going" so that museum directors can stay abreast of Fontana's work. "All I've shown them is that the work is great and if they like it, I'll be glad to put them in touch with the artist," he explains. The last part of the agent's contact with a museum comes when it must raise some money. As Riva says, "It's the job of the agent to come back in and help to find out in which direction the museum wants to go, whether they want a single sponsor or multiple sponsors." Once the museum decides to give the artist a show, Riva adds, "You put your hand in your address book." When the museum commits itself, "you'll find a lot more interest in people."

NONCOMMERCIAL PROJECTS
Some representatives and dealers do not get involved in any commercial ventures whatsoever. After spending four years working with New York's Light Gallery and five years dealing on his own, Rick Wester now works closely with the Pace/MacGill Gallery in New York, universities, museums, and corporate and private collectors. Wester offers exhibitions of his artists' work by appointment, primarily to clients who want to add to their collections. One of Wester's clients, for example, collects images that reflect his experiences in the United States. Mark Klett's photographs fulfilled this collector's needs perfectly. Wester has also arranged for Klett's work to be shown in the Pace/MacGill Gallery.

Wester finds that collectors buy single photographs as well as bodies of work. He explains:

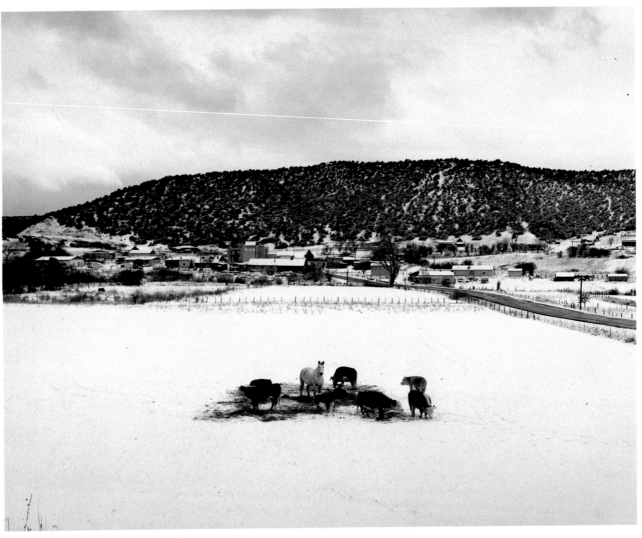

Las Tampas, N.M.
© March 1982 Alex
Harris. Courtesy of
Rick Wester
Photographic.

"They like to know that the work is part of a limited edition for they are predominantly people educated in photography." But, he adds, "The photographer has every right not to limit editions." Wester believes that the market for photography is strong and expanding. He points to the great increase in interest in the Creative Center for Photography in Tucson, Arizona, as well as in Phoenix, Houston, San Francisco, and Los Angeles.

Wester accepts for review the work of photographers who have been recommended to him by his clients or by other dealers and photographers. He represents photographers whose work is color or black and white, traditional or abstract. His commission varies between 30 percent and 50 percent.

Janet Borden is also a New York-based representative and dealer who works with both private and corporate clients. She represents contemporary photographers to the market energetically and enthusiastically. After three years at the George Eastman House in Rochester, New York, and four years at Robert

Freidus' gallery, Borden decided to represent photographers on her own.

Two considerations top the list of priorities for Borden's clients: limited editions and the fading of images. Although corporate clients buy in large volume and spend a great deal of money, Borden says that "private clients are a smaller group, loyal. And they love the photography I have to show them." She adds, "The museums buy one photograph at a time, but museum sales are very important for the photographer's career." Borden believes that exhibiting a photographer's work is also critical; in fact, scheduling shows is her primary goal. Some of the photographers she represents have been included in collections at New York's Metropolitan Museum of Art, Museum of Modern Art, and Eastman House, and Houston's Museum of Fine Art. Borden also arranged for Tina Barney's photography to be shown in The 1987 Whitney Biennial. Borden's photographers have also enjoyed exposure through exhibitions at such galleries as Barbara Toll, Tatistcheff, and Barry Whistler in Dallas.

One Lomb
Memorial Drive,
Rochester, NY,
January 1979.
© 1979 John Pfahl.
From *Picture
Windows* by John
Pfahl.

The Birthday Cake.
© 1986 Tina Barney.

Borden represents photographers from anywhere in the United States but only accepts work from photographers recommended by other photographers she knows or by colleagues. The overwhelming majority of the work she represents is contemporary, and color images and large-format photography—16 × 20 and larger prints—are in the greatest demand. Borden's standard commission is 50 percent. When she works with a gallery, however, the gallery receives 40 percent of the purchase price and Borden receives 10 percent.

Robert Mann founded New York's Foto Mann, Inc., in order to become a private, noncommercial dealer. Mann, who had worked with Harry Lunn in Washington, DC, for six years, now lists museums, universities, and private and corporate collectors as his major clients. His business philosophy benefits the artists: "Because I don't have a public space, I don't like to represent too many photographers. I don't want to dilute the impact of those I already work with."

Many of Mann's clients prefer limited editions because they protect the collector and the photographer. "The photograph in a limited edition is easier for me to sell, and it allows the photographer to move into new areas," explains Mann. Simply put, limited editions in the marketplace offer a safe investment and added security for all. Concerning the demand for large-format photography, the dealer says, "In many cases I do applaud that movement, especially with color to meet the decorative trend." His reaction stems, in part, from the various solutions to the color stability problem, such as dye-transfer and Cibachrome.

In order to be represented by Mann, a photographer must be referred by a client or another photographer whom Mann knows. He does not, however, require that the work reflect any particular theme or style. Mann determines the price of a photograph with the photographer and receives a 50 percent commission.

Marvin Heiferman has been an artist's representative for more than six years. He sells photographs to corporations; he also refers collectors to photographers whose work is more unusual but is not being shown and to photographers who produce the type of work sought

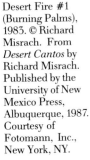

Desert Fire #1 (Burning Palms), 1983. © Richard Misrach. From *Desert Cantos* by Richard Misrach. Published by the University of New Mexico Press, Albuquerque, 1987. Courtesy of Fotomann, Inc., New York, NY.

after. Like many photographers, Heiferman has learned that travel is an important part of his work. He finds Los Angeles and New York to be "the most active" cities in terms of the market. He is also impressed by the art market in France, a country whose photographers, he says, are "very serious."

Heiferman was the director of Castelli Photographs for seven years and the assistant director at New York's Light Gallery for more than two years. Heiferman assesses the photography market less optimistically than some other dealers have; he maintains that "art photography does not provide a living to anybody." Heiferman also believes that "different kinds of work need different kinds of exposure." Ralph Gibson's reputation, Heiferman points out, was established through books. Similarly, Sandy Skoglund succeeds with exhibitions, and Nan Goldin's work excels in slide shows. Without a doubt, proper exposure is the essential ingredient of photography.

AGENCIES

Photographic agencies facilitate the exchange between photographers and those who need their work. Agencies usually represent a large number of photographers to a large number of clients. Within their network is often a need for photography ranging from highly graphic to abstract. Otherwise, they prefer a particular kind of photography. All agencies, however, look for a large quantity of good photography that is unique to the artist.

Photo Researchers, Inc., a New York-based agency, represents photographers via a tremendous network. In addition to being a resource for fine stock photography for more than thirty years, Photo Researchers is affiliated with Japan's finest photography agency, Pacific Press, which represents Hiroshi Hamaya, who recently had an exhibition at New York's International Center for Photography, and France's RAPHO Agence du Presse, which represents, among others, Doisneau, Boubat, and Ronis. Photo Researchers is also associated with other agencies in Germany, Italy, Australia, Spain, and the United Kingdom.

Suzanne Goldstein, the liaison between foreign photography agencies and Photo Researchers, points out that while the agency uses primarily pictorial photography, abstract photography does have its uses. Surprisingly one such use has been textbooks. Arthur Tress' work, for example, while pictorial, extends into the realm of the abstract with his manipulation of his images. Photo Researchers has been able to place his work in psychology textbooks. A pictorial image taken by another photographer whom the agency represents was also useful in an unexpected way. Dr. Georg Gerster, a pho-

tographer based in Switzerland with an international reputation for aerial photography, created a photograph that actually boosted land conservation. Gerster had photographed a farm near Pomeroy, Washington, that was taking exemplary measures to combat erosion. After he showed the aerial shot to David Hein, a Soil Conservation Service officer, in order to get technical advice, Hein had the photograph enlarged and hung it in his office. "Then it was seen by a farmer who up to that time had stubbornly refused to save his 2,000-acre farm," explains Gerster. "He looked at it for a while, then told David that he and his office from now on had a free hand 'if you can make my farm look as fantastic as that one.' "

Goldstein explains Photo Researchers' distribution policy:

> If the photographer does not have a foreign agent, we distribute their work through our agents. We handle a wide range of so-called stock photography, including natural history, science (from bacteria and cells to high technology), travel, general editorial, and advertising subjects. Because of the affiliation with RAPHO and Pacific Press Service as well as other foreign outlets, our photographers' pictures have the potential of going into calendars, books, magazines, exhibitions, and advertising throughout the world.

Photo Researchers, according to Goldstein, is "always looking for new photographers." The agency prefers to see 300 to 400 color images and/or 100 black-and-white prints. Both original slides and high-quality duplicates are accepted and can either be delivered in person or sent through the mail. Photographers are encouraged to write for submission guidelines and a sample contract and to set up an appointment. Photo Researchers receives a 40 percent to 50 percent commission.

Art and Commerce is another New York-based agency. It was founded in 1983 by former dealers Ann Kennedy and James Moffat. While also working as a curator, Kennedy realized that one of the Man Ray images she was selling for $20,000 had been taken, in fact, for a commercial job. Since it seemed logical that the mixing of art and commerce continue, she and Moffat formed the agency for photographers interested in finding commercial work. "They can make as much money in two days as they can in six months of selling prints," she explains. Art and Commerce represents, among others, Annie Leibovitz, Steven Meisel, Robert Mapplethorpe, and Laurie Simmons.

Adhering to its premise that fine art is compatible with commercial and editorial projects, the agency finds unique work for its photographers. The assignments fall into the commercial photography category and make no attempt

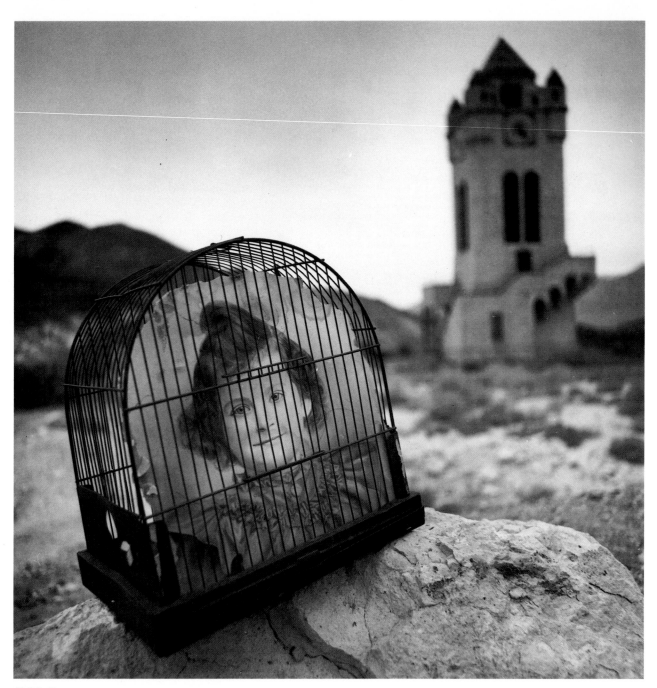

Child's Dream,
Death Valley, CA,
1978. © Arthur
Tress.

to be anything else. There is, however, a rare opportunity for self-expression. In addition to still lifes and portraits, a great deal of Art and Commerce's business is fashion shooting. "Fashion photography is a great opportunity for creative photography," says Kennedy. She finds that European magazines, such as the Italian edition of *Vogue*, are highly receptive to the photographer's initiative.

In order to be considered by Art and Commerce, photographers should call for an appointment to drop off their portfolio, which can often be picked up later the same day. The agency receives a 25 percent commission.

Corporate Art Directions represents clients in selecting, appraising, and installing art. "Corporate Art Directions has no affiliation with any gallery, artist, or publisher," explains company president Betty Levin. According to Levin, photography is one of the art forms that the firm recommends to its clients (primarily corporations and banks) because young photographers' work is affordable and upgrades any art collection, and because "photography is an art form which is here to stay."

Some of the company's clients buy in volume, while others buy just one print. Corporate Art Directions has sold collections of photography to such clients as Banker's Trust and the law firm of Wilkie, Farr and Gallagher, and has sold over 350 photographs to First Boston Corporation. "Sometimes we can get a client to mix their collection, such as not putting together exclusively a collection of landscapes or cityscapes," adds Levin. The firm's clients seem

to prefer large-format photography, starting with 16 × 20 prints.

Corporate Art Directions, in addition to encouraging collections of drawings, tapestries, watercolors, and oils to its clients, has files of photographers' work on hand. The company also consults such representatives as Janet Borden, Marvin Heiferman, and Rick Wester. "We use as much black-and-white photography as possible and as much abstract photography as I can get away with," adds Levin. "The only kind of photography we can't use is political or sexual."

When submitting work to Corporate Art Directions, photographers should send several pages of duplicate slides. (A photograph of a sunset or the Statue of Liberty had better be beyond exceptional.) If the material is approved, prints for viewing will be requested to determine print quality. A final note: Corporate Art Directions does not represent photographers. When a photographer's images seem to fit a client's request, they are presented.

Art Placement International, an organization of artists' representatives, was founded in New York in 1980. Although the company represents both artists and collectors, its primary concern is the collector. Company president Cynthia Gibbons explains:

Corporations really need people to help them get a good collection together, particularly law firms. They love to have lots of images at low cost, something very sleek and sophisticated, on target and today. And that is what photography is.

Tea Kettle at Sunset. © 1980 Charles B. Seton, Jr. From the collection of Art Placement International. Courtesy of the Harvard Business School.

© 1982 Roger R.
Ricco. From the
collection of Art
Placement
International.
Courtesy of Aetna.

Gibbons does not mince words about the role of the artist's representative: "Our job is to represent the artist when our clients are looking for a specific kind of work." She is also blunt about the subject of exclusivity. "The minute we sign a contract and say 'You are ours alone,' we are doing the artist a disservice because we are not going to do catalogs. We are not offering advertising," Gibbons says. "We're like a library. If they are part of our library, then we will do everything to give them exposure. But our allegiance is to the client, getting the right thing to the client." Art Placement International's many clients include Harvard Business School, Equitable Life Insurance, American Express, Warner Communications, Estee Lauder, and Merrill Lynch, and Aetna.

Art Placement International, like other agencies, looks for unique work. The company sees at least twenty artists a week, in addition to reviewing slides and resumés from all over the world. Gibbons explains that the reps can hold up a sheet of slides and determine almost immediately if a photographer's work is derivative or not. If they feel it is, they slip the sheet back into the envelope and return the art. If the work warrants a second look, it is projected and examined carefully. If the work gets through this phase, it goes to committee for review. The artist is then asked to come in to make a presentation or to receive some of the company representatives at his or her studio. Selections are then made as to which images will be placed in the books or drawers as samples of the photographer's work.

In order for their work to be considered, photographers should submit duplicate slides or prints. Art Placement accepts only realistic and impressionistic images, not figurative ones. The organization receives a 50 percent commission.

SELF-REPRESENTATION

Self-representation, the alternative to external representation, can be time-consuming: it may require you to make three trips to the framer because there is still dust between the glass and the photograph. Although such a problem can also happen if you have a rep, the rep should take care of it. Without a rep, you must solve the problem. But self-representation can also be advantageous; it is potentially lucrative, and it guarantees you complete artistic control. You, the photographer, are ultimately responsible for the perfection of the final "product." You will find out quickly whether or not the profits, the control, and the freedom that come with self-representation are worth the time you will have to spend away from your photography.

Working as your own representative can be creative and educational. When going it on your own, it is essential to communicate effectively, both on the phone and in writing. Introduce yourself, and stress your uniqueness. Be direct. Get an appointment. Show your work, and then move on to the next potential client. Most people who look at your portfolio will not waste their time or yours by being polite. Most people, very much like yourself, are tired of clichés and mediocre photography. However, everyone's definition of "mediocre" is different. While hearing others' opinions about your work is often valuable, knowing the source of those opinions is invaluable.

All photographers, but especially those who represent themselves, must be careful about reproduction quality. For those photographers represented by prints that they themselves have produced, David Rajwan of New York's Spectra Photo Lab offers some advice, a result of ten years of experience:

> The quality is not based on the use of an original slide. It is the printer. The printer can determine the colors, the sharpness. It's true that with every generation you are losing something. But there is a lot that can be done with duplicate slides. I can show you instances where the duplicate is better than the original. If the color is off, with a good duplicate the most you will lose is 5 percent. And this can be corrected.

Rajwan has a few suggestions for photographers who represent themselves. Slides that won't be looked at everyday should be stored in metal boxes. Slides that will be used fairly frequently should be kept in archival pages. For slides you'll want forever, make duplicates, work with the duplicates, and put the originals in a safe. Rajwan also recommends using Cibachrome or Ektacolor Plus materials. They have remarkable color stability; this longevity has proven them sound enough for even the most skeptical collectors.

Photographers contemplating self-representation should also be aware of the following. Cards sent to prospective clients can hurt as much as help. A photographer's work is best represented by the body of work itself. Slides—assuming that you never send out anything but duplicates—aren't acceptable. For most viewers, the size often does not translate into a format any larger than the slide itself. Careful negotiation about pricing and control is critical. Keep in mind that in a limited edition, the price goes up as the edition runs out or with an increase in popular demand. As Elena Prohaska, a member of the Appraiser's Society, points out: "If photographers can afford to lower their prices to start, they can always raise

the prices later. It's not a good idea to scare off their market." And, whether you are negotiating a contract for a book, a series of postcards, or a gallery sale, be sure that acceptable terms for artistic control and royalty fees (or a fair lump sum paid upon signing) are included.

A final point about self-representation: more and more potential collectors and galleries now prefer a recommendation if not a rep. If you are a photographer whose business sense supports your photography, you may as well keep it your own business and represent yourself. Get recommendations. Find a network of colleagues.

WRITTEN VERSUS ORAL AGREEMENTS

Only a fraud will tell you that you don't have to get all agreements in writing. There is always a gallery curator, an overzealous independent dealer, or a company representative who can urge you to put together a collection of ten 16 × 20 Cibachromes for an exhibition or a sale. Then the person's mood and interest change. You have already invested time and money in the production. What can you do when the show is called off? There is nothing you can do if the agreement was an oral one. Chalk it up to experience. Eventually, and optimistically perhaps, you'll sell the photographs. But always remember that it is no secret that photographers are hungry for shows and work. Many people are ready and willing to take advantage of "impractical" artists. Photographers, by virtue of their overwhelming number, are often regarded as willing to work for nothing.

Written agreements are imperative, and all of the details of the agreements should be spelled out. This is essential whether you are setting up a private corporation or simply selling your photography yourself. Representatives have already learned all the ropes that can trip you up. When you deal successfully and independently, the commissions go to you alone. Indeed, the profits are greater, but so are the inherent risks and headaches. A good lawyer who is also a colleague, acquaintance, or friend can make your negotiations much easier and much more advantageous.

Photographers have been sued by models because they did not fulfill a promise of fame and fortune. Others have been sued for breach of contract. When Harvey Edwards was starting out in the late 1970s, he hired models and signed numerous standard model agreements. This process always was, and for the most part still is, cut and dry. Then in 1978, a year in which the poster market was weak, Edwards put up thousands of dollars to produce posters. His wife supported him so he could continue his work. When the posters finally took off, Edwards was able to recoup some of his money

and see some profit. Suddenly the models were back, claiming rights to the profits. As Edwards points out, "At any moment, the success can be taken away from you. The ASMP guidelines are there, but they don't protect you. So you get taken by somebody else's greed." The photographer has already spent over $20,000 defending himself against the models' lawsuits, "and we're not yet even to base one."

Photographers have sued other photographers for "using," "appropriating," or, as some would say, "stealing" their previous endeavors. This is a big problem with the current trend toward "appropriated imagery." A judge must determine whether the image in question has been changed by the required 20 percent or more for the usage to be legitimate. Because of photography's relatively new position in the world of fine art, as well as its highly reproducible nature, few legal precedents apply. Lawyers' fees can turn out to be much greater than the reimbursement for the misappropriation. "Unless you have a lot of time and a lot of money, you become a loser," comments a well-informed Harvey Edwards. Remember: anything someone agrees to orally, he or she should be willing to agree to in writing.

FUNDING

All photographers, whether they represent themselves or are represented by others, can use additional ways to finance their photography. This is especially true for photographers who are at an experimental stage—photographers who are involved in an unusual photographic project or are deciding if photography is their medium of choice. A grant may be in order. Funding can help move you along a direction to its natural end without commercial interruption.

Every state supports the arts through various programs. All state agencies have applications that must be filled out, filed, and examined. Most of the support takes the form of fellowship programs for individual creative artists. Educational, cultural, and community organizations offer artist-in-residence programs. Artists' New Works funding provides advisory and fiscal services for professional artists who are developing individual projects. There are also short-term, low-interest loan services for nonprofit cultural organizations and public advisory services.

New York State, for example, has a foundation for the arts. Any photographer applying for one of its fellowships cannot be a student and must be at least eighteen-years-old. Each fellowship award is now approximately $5,000; this figure is expected to rise. About 200 fellowships are awarded each year. Every fellow-

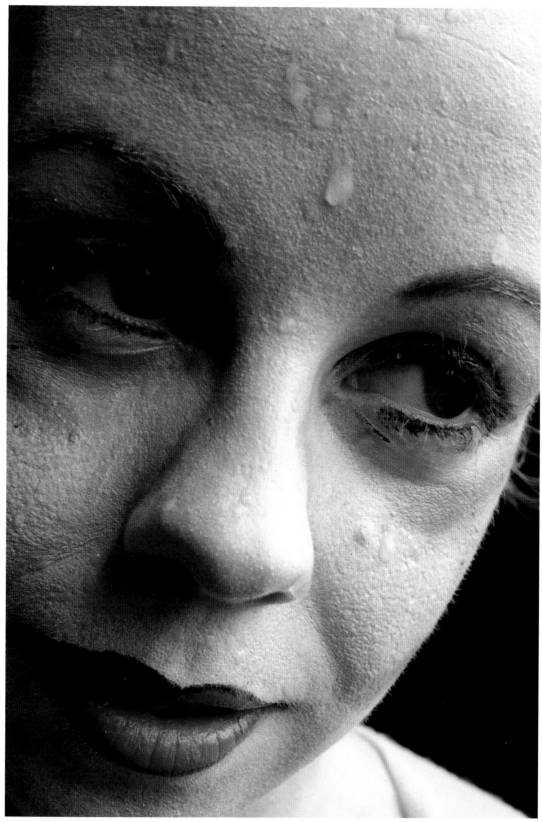

Night Performance.
© Harvey Edwards.

ship recipient works with the community to develop a public service activity.

The United States Government also is a patron of the arts. The competition for funding by the National Endowment for the Arts, an independent agency of the federal government, is open every two years. The percentage allotted to each of the budget's categories of the arts is not determined until the need in each category is reviewed by the board. The "photography" category has a jury that is separate from the "art" category, which includes sculpture and other forms of printmaking.

All United States citizens and foreign nationals who have become permanent residents of the United States are eligible for endowment assistance. Over the past several years, The National Endowment for the Arts has received an average of 5,000 "visual artist" applications each year, of which only about 5 percent have been funded annually. (For further information and an application, contact The National Endowment for the Arts, Nancy Hanks Center, 1100 Pennsylvania Ave., N.W., Washington, DC 20506.)

Another source of financial support is, The Guggenheim Fellowship program, which was established in 1922. The amount of the grant is determined by the artist's need, his or her other resources, and the purpose of his or her plans. Be aware, however, that Guggenheim fellowships "may not be held concurrently with other fellowships." These fellowships, among which there are eighty-one categories of creative arts, are awarded annually. Photography receive one-tenth of the funds for creative arts.

Regardless of the source of financial support, funds filter through our fingers and lenses into the quality of our work. Grants ultimately benefit the photograph and the finished project, increase the satisfaction of the photographer, and advance the state of the art.

INDEX

Page numbers of illustrations are italicized.